digital:photography:
handbook

a user's guide to creating digital images

Tim Daly

WRITER'S
DIGEST
BOOKS

digital:photography:
handbook

a user's guide to creating digital images

A QUINTET BOOK

First published in North America
in 2000 by Writer's Digest Books
an imprint of F&W Publications, Inc
1507 Dana Avenue
Cincinnati, OH 45207
1-800/289-0963

ISBN 0 89879 945 7

Quintet book code DGPG

Conceived, designed and produced by
Quintet Publishing Limited
6 Blundell Street
London N7 9BH

Editor: Amanda Leung
Art Director: Sharanjit Dhol
Designer: Ian Hunt
Photographer: Jeremy Thomas
Illustrator: Richard Burgess
Montages: Rise Design

Creative Director: Richard Dewing
Publisher: Oliver Salzmann

The Publisher would like to thank AGFA-Gevaert Ltd. for supplying the
images on pages 9, 12, 28, 32, 39 and 46. These have been
reproduced from the AGFA publications *A Guide to Digital
Photography*, *The Secrets of Colour Management*, and *A Guide to
Colour Reproduction*.

Thanks also to Leo Manning Jones at Applecentre, Brighton & Hove,
for the loan of Apple equipment.

Typeset in Great Britain by Central Southern Typesetters, Eastbourne
Manufactured in Malaysia by CH Colour Scan Sdn. Bhd.
Printed in China by Leefung-Asco Printers Ltd.

KEY

Photo parallel

Creative ideas

Step-by-step

Settings recipe

Best buy

Keyboard shortcut

Essential tools

Fine tuning

Web links

Reference

How it works

Core principle

Darkroom techniques

>>>CONTENTS

Introduction:
>>> Why digital?

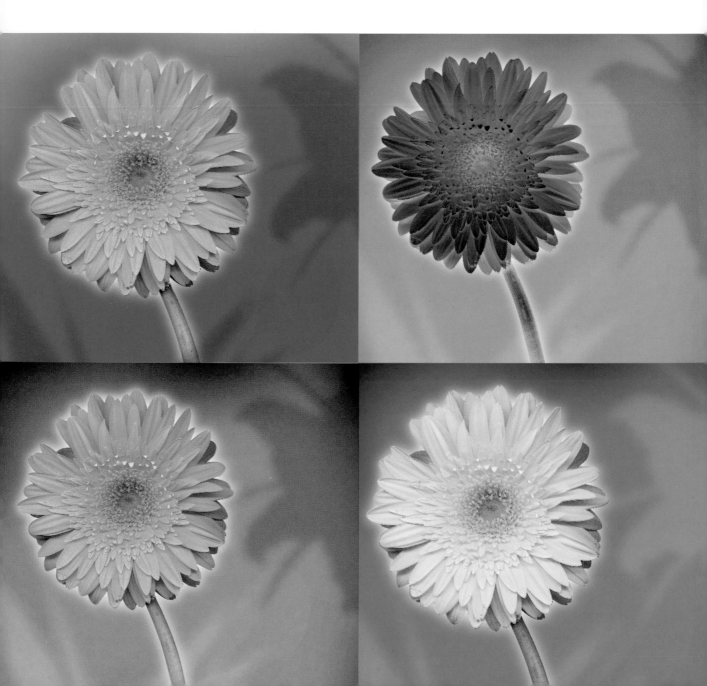

Looking back at the rapid evolution of photography from Fox Talbot's crude salt prints of the 1840s to today's sumptuous color prints, the obvious question is: why do we need digital imaging?

Digital imaging will never replace traditional photography, just as photography never heralded the end of painting. It will, however go some way to enabling fine photographic printing to be perceived as an art form rather than as a complex technical skill. Using an imaging workstation enables photographers to realize, for the first time, their projects in a multi-purpose format: the digital image, which can then be printed onto paper or fabric, projected as a presentation, e-mailed across the globe, or displayed on the World Wide Web. Whether students specialize in design, painting, photography, or textiles, digital imaging allows the exciting crossover between previously separate disciplines. Contemporary image-makers are equipped with the most sophisticated creative tools ever invented.

To take advantage of all this opportunity, new users need a clear basic overview of the technology that underpins the practice. As every photographer knows, a thorough understanding of systems and materials enables full concentration on the most important issue: making great images, and not worrying about whether it's going to work.

Digital imaging does not require experienced photographers to start learning all over again. In fact, photographers are already some way ahead of other users, with good understanding of color balance, density, and tonal reproduction.

In the professional world, digital imaging has already become well established in press and journalism photography, where fast transmission of images by laptop and digital mobile telephone enables picture desks to have images back from location within minutes of the event taking place. In materials-intensive applications, such as brochure photography, high film costs have been avoided with the use of a digital studio camera. Photographers' jobs, too, have changed, with the possibility of "packaging" images for direct reprographic output and use over the Internet.

For photographers, a digital imaging workstation can be Ansel Adams' darkroom and Man Ray's studio at the tips of their fingers. The creative opportunities of digital imaging will form the basis of this book and my emphasis will be placed on the visual enhancement of images. This exploration of how to make a good image that much better, should inspire new users to experiment with all the possibilities this process affords.

digital:photography:introduction

Chapter 1:
>>> Hardware

>>COMPUTERS

The term "hardware" refers to the physical units of a computer system such as the monitor, mouse, and computer processor.

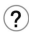

With the continued increase in computer specification and performance, it is now possible to buy a computer for digital imaging for not much money at all.

> Processors

The major components affecting the performance of a computer are the Central Processing Unit (CPU), the bus speed, and the quantity of Random Access Memory (RAM) and storage installed. A processor calculates the complex commands that manipulate data, with a speed measured in megahertz (MHz). One megahertz represents one million instructions per second. Nowadays computers are sold with processors such as the Pentium III and the G3, capable of 300–450 MHz and upwards. Since the calculations for image processing are long and complex, the faster the processor works, the faster you can work. On older machines with slower processors, it was not uncommon to wait several minutes for a simple task such as the rotating of an image.

Performance also relies on the type of bus installed. The bus is essentially the internal network of wires that transports instructions from the processor to other areas, such as the hard disk and RAM area. A fast bus is like an eight-lane highway, able to carry lots of traffic quickly, without causing congestion.

Memory capacity is measured in bytes and usually quoted in a computer specification in megabytes (MB). A byte consists of 8 bits; a bit is the smallest unit of digital information.

> Memory and storage

The precise meanings of these two terms overlap, but are best understood as follows: memory is the area of a computer where data is held for quick access; and storage is a separate area where less urgent data is written to and retrieved from. Random Access Memory is a removable chip, housed close to the processor.

Image © AGFA

Accelerators
Video accelerators can increase the speed at which the computer redraws the screen when changes are made or can speed up particular functions in image-editing software. Both can produce significant boosts in productivity.

VRAM
The amount of VRAM (video RAM) controls how many colors the computer can display on a monitor and how large a monitor it can support.

The CPU
The central processing unit (CPU) is the part of the computer that actually does the work. Current Macintosh computers use PowerPC or Motorola 69040 chips; Windows PCs use Intel's 486 or Pentium chips.

RAM
Dynamic Random Access Memory (RAM, or DRAM), holds programs and files while you work on them. Extra RAM can greatly speed your work on image files.

Hard Drive
A workstation's hard drive stores the programs and data files used on the computer. Hard drives can now hold a gigabyte (1,000 MB) or more, of data. Extra storage can be added in the form of additional hard drives or other units such as removable cartridges or optical disks.

1. Monitor.
2. Computer: the hard disk drive is inside the box.
3. Speaker.
4. Expansion bay for optional storage devices.
5. Floppy disk drive.
6. CD–ROM drive.
7. Keyboard.
8. Mouse.

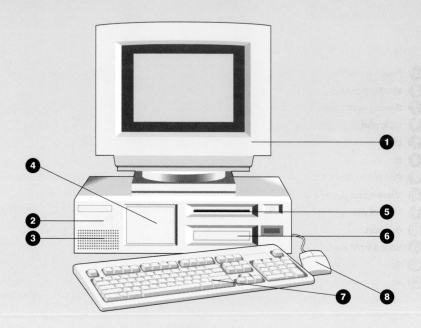

RAM stores the system software, the open applications, and the open data files while you work on a project. This data is lost when the computer is turned off, so saving your data to a storage area beforehand is essential before you shut down. The hard disk is an area where dormant data such as closed applications and image files are kept until they are needed again. RAM is not visible, unlike the hard disk which is represented by a desktop icon. The hard disk is a mechanical unit which spins when data is written to and read from it. Data can also be stored on removable media, such as disks and portable hard drives, which are useful for transporting large amounts of data between two workstations. The rate of transfer to the portable storage device can have a significant bearing on the speed of your workstation.

> Architecture

The processor, RAM, and hard disk are all fitted to the motherboard, which also has empty slots to add extra RAM or performance-enhancing cards (PCI), or extra functions such as sound and graphics cards. Most computers are sold with the bare minimum of RAM, but with a number of

> Purchasing considerations

>>> **Upgrading** Good computers are designed with upgrading in mind. Your computer should have removable front panels to allow additional drives, such as internal Zip drives or a CD writer to be added at a later date. Extra RAM chips can be added into vacant slots, and most upright or tower computers will have one side panel which opens out to allow easy access to these areas. With flat or desktop models, the removal of the outer case may be trickier. Adding extra RAM is a straightforward operation and can be carried out by novice users, providing careful attention is paid to the guidelines.

>>> **Mac or IBM PC?** Traditionally Apple Macintosh computers were used by designers and publishing professionals as the Mac icon-based operating system was simple to use. Nowadays IBM PCs (personal computers) run with the latest Microsoft

1. Power socket.
2. Monitor power.
3. Security lock ports.
4. SCSI port.
5. Ethernet port.
6. Ethernet port.
7. Printer port (GeoPort).
8. Modem port (GeoPort).
9. Monitor port.
10. Bus port.
11. Sound input port.
12. Sound output port.
13. Access covers for expansion slots (3).

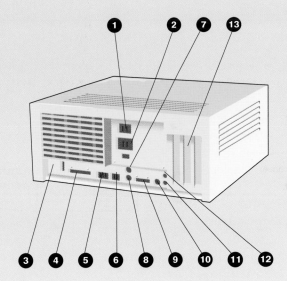

empty spaces to add further chips if necessary. RAM chips are sold with a design to fit specific makes and models and are available in different capacities such as 32, 64, and 128 megabytes (MB).

> Built-in drives

3.5-inch floppy disk drives are not useful for imaging purposes, but are useful for transporting small word processing documents; some manufacturers have decided to leave them off their products altogether. Hard disk drives are usually housed internally and nowadays are supplied in gigabyte (GB) sizes. Large disk sizes are useful for storing many large image files. CD-ROM (compact disc read-only memory) drives are now standard, and their performance is described in reading speeds such as 8x, 16x, or faster. CD drives are able to read a wide variety of media including music CDs and Photo CDs. Most new software that is produced is commonly supplied on CD-ROM. A recent development is the digital versatile disc (DVD) drive, which is capable of playing higher capacity DVD discs as well as conventional CDs.

Windows system software, which is just as simple to operate. Apple have not licensed their operating system to any third party manufacturers, so Mac computers are manufactured only by Apple and have a highly consistent set of internal design standards. Printers and scanners produced by third party companies for the Mac, are designed therefore to fit these common standards. IBM PCs, however, are constructed by many companies from a myriad of motherboard, processor, and drive configurations, and adding compatible memory, scanners, or printers to a PC can be more problematic for a new user. Macs may appear to cost more than PCs but they are often supplied with built-in Universal Serial Bus (USB), sound, or video cards. If designers and photographers new to digital imaging want to keep their involvement with hardware compatibility issues to a minimum, then an Apple Mac may be the best and most straightforward choice.

>>MONITORS

Human vision is fast, high resolution, and able to detect a seemingly infinite range of colors. A computer monitor, however, is much more limited.

Inside the monitor's shell is a cathode ray tube (CRT), which looks like a light bulb with a flattened end panel. The inner surface of this flattened end is coated with phosphors, which glow and produce light when hit by an electron beam. Three colors of phosphor are present: red, green, and blue, and are arranged in clusters of three, called triads, with one triad for each screen pixel. Different colors are created when the RGB phosphors are excited with different values.

The sharpness of the image created on the screen depends on a kind of internal stencil screen called a shadow mask. A shadow mask is a thin sheet of metal with minute perforations, which help to direct the electrons to the phosphors. Trinitron tubes have a unique shadow mask based on fine wires, which creates a sharper display image.

The image you see on the monitor screen will never equal the printed version and it is wise to accept this fact before starting. Screen images are displayed as transmitted RGB light, and most printed images are viewed as reflected light from cyan, magenta, and yellow inks or dyes. For serious imaging work, a good monitor and graphics card, which allows the display of a color palette of millions, is a crucial piece of equipment.

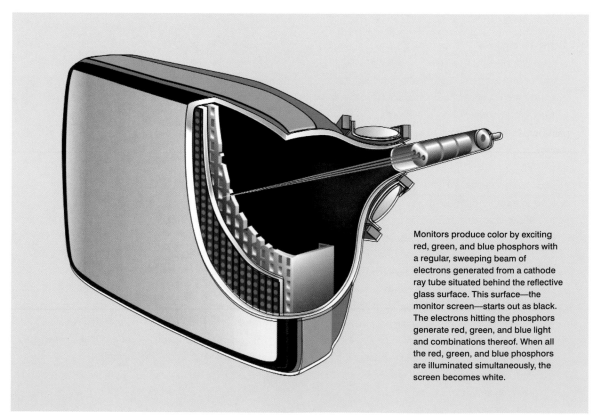

Monitors produce color by exciting red, green, and blue phosphors with a regular, sweeping beam of electrons generated from a cathode ray tube situated behind the reflective glass surface. This surface—the monitor screen—starts out as black. The electrons hitting the phosphors generate red, green, and blue light and combinations thereof. When all the red, green, and blue phosphors are illuminated simultaneously, the screen becomes white.

Image © AGFA

›Purchasing considerations

>>> **Refresh rate** Monitor flicker can be disconcerting, and is usually caused by a low refresh rate. Monitors with a refresh rate of 70 Hz or over are flicker-free and are essential for imaging work.

>>> **Dot pitch** This describes the distance between the perforations on the monitor's shadow mask. The smaller the number, the sharper the image will be. Better displays usually have a dot pitch under 0.28mm.

>>> **Trinitron-based monitors** These are able to display sharper images due to a different kind of shadow mask, one based on a grid of thin wires rather than a punctured metal plate. A telltale horizontal thin black line, two-thirds of the way down the screen, denotes a Trinitron monitor.

>>> **Compatibility** Most monitors come with a standard plug that fits most PCs. Macs can support third-party monitors with a simple adaptor.

>>> **Video RAM** This is a separate piece of high-speed memory added to a graphics card that stores the screen data and is essential for a high-quality display. VRAM chips are inexpensive and can be installed easily to maximize the potential of your workstation.

>>> **All-in-ones** Some computers, such as the iMac, have a built-in monitor and are compact and easy to store. The screen size, however is relatively small, and although the iMac could be useful for a novice, a larger screen will eventually become necessary.

>>> **Size** Buy the largest monitor you can afford and keep to established manufacturers such as Sony, Mitsubishi, and La Cie.

Monitors have a much smaller dynamic range than prints and film, and are not able to display the deepest shadow tones or special printer's ink colors. The spatial resolution of a monitor is normally between 72–75 dots per inch (dpi), and an additional value is often quoted describing the pixel dimensions such as 1152 x 870. Monitors for precise imaging work should be used with a color display of not less than thousands of colors, however millions of colors are preferable. Lesser color displays such as 256 colors will force your high quality image file into a crude and posterized version on the screen. To achieve a monitor's maximum display resolution and speed of display, additional video display cards or Video Random Access Memory (VRAM) may be needed. Large monitors are good for imaging since professional applications such as Photoshop have many palettes and menus which take up a lot of screen space, leaving little room for your image. 17-inch monitors are a must, and larger sizes are even better. On many computers it is possible to add a second monitor, which could be smaller and of lower quality, used only to display Photoshop's palettes, leaving the bigger monitor to display a full screen image.

Laptops have a different kind of screen called a Liquid Crystal Display (LCD) which has even less of a dynamic range than a normal CRT monitor. Although laptop screens allow millions of colors to be viewed, laptops should only be used for previewing images on location. Standard monitors can be plugged into laptops for a better display when returning from a shoot.

Flat panel monitors are a recent development and many use a new screen technology called Active Matrix, which delivers a better color image than older LCD screens. High-cost models may also have a higher resolution beyond 100 dpi.

>>OPERATING SYSTEMS

Windows NT and 98, Mac OS, and Unix are all systems designed to control the complex operations performed by a computer.

The Operating System (OS) is a skeleton which enables software to interface with computer hardware and which also enables the computer to perform a number of routine tasks, such as formatting a disk and erasing files. Modern system software demands a significant amount of RAM to work correctly, and it is worth subtracting this figure from your total RAM to get a better idea of the space available for your imaging application. System software is regularly upgraded to include new functions and take account of the latest software standards and ever-increasing innovations.

Software such as Adobe Photoshop is sold in different forms for Windows, Mac, and Unix operating systems and is not interchangeable.

IBM PCs are usually sold with the latest version of Microsoft Windows as standard, and Apple Macs come pre-loaded with the latest version of the Mac OS software. Unix is usually reserved for more powerful machines such as Silicon Graphics workstations, used for digital video editing, 3D-animation, and in other processing-intensive environments.

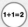

>>> **Icons** Mac and Windows Operating Systems use icons, or small pictures, to represent files and directories. Icons are like buttons, and double-clicking one opens or launches the application it represents. Icons can be clicked, double-clicked, or dragged to instigate a variety of commands, making the operation of the computer easy, even for a novice.

>>> **Window** A window is a frame which contains a single image or text file within an open application. The edge of the window denotes the boundary of the active working area and if the screen is large enough, several separate windows can be displayed side by side. With Adobe Photoshop, many separate image files can be open at the same time.

>>> **The desktop** This is the virtual work surface on which important icons such as the Macintosh Hard Disk and Wastebasket or, on Windows, My Computer and Recycle Bin, can be found. This display is usually your starting point after your computer has started up correctly.

>>> **Driver software** When a device such as a scanner or a printer is connected to a computer, an extra piece of software called a driver needs to be installed to enable mutual recognition and communication. Drivers are designed to make specific models work with specific versions of system software, and an incompatible driver is a common problem for computer users. When purchasing scanners, printers, or other peripherals, check the compatibility with minimum hardware requirements and operating system versions.

>>> **Upgrading operating systems** Caution should be exercised when upgrading system software, since many device drivers for scanners, printers, and digital cameras are designed to work with a specific version of the operating system. The advantage of updating your system software may be outweighed by the disadvantage of having to update all your drivers. Patches and driver upgrades are usually small files and are available free of charge from the device manufacturer and can be easily downloaded from their website.

>The Windows "NT" desktop

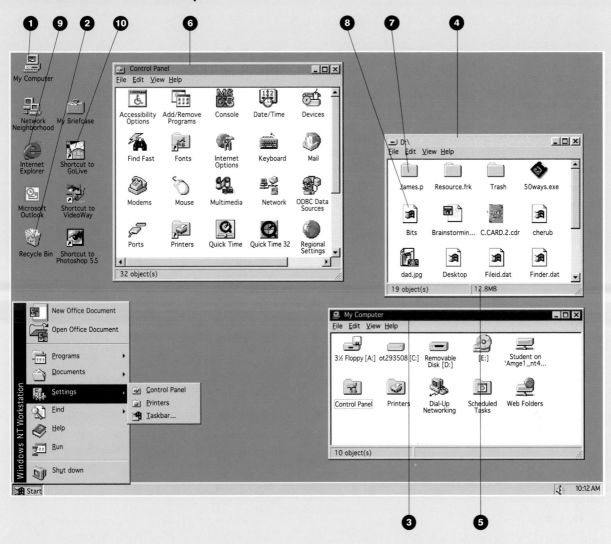

1 My Computer icon.

2 The Recycle Bin icon where you drag
and drop items you no longer require.

3 My Computer window showing the
available hard drives, disk drives, and
networked drives.

4 D drive window shows the contents of
the 10 objects on the Zip disk.

5 12.8MB is the total data size of the 10
objects on the Zip disk.

6 The Control Panel window showing
icons for managing your computer's
hardware and software.

7 Folder icon.

8 Document icon.

9 Application icon.

10 Desktop shortcut icon for Adobe
GoLive. Double click to launch.

>The MAC OS desktop

1 The hard disk icon.

2 The wastebasket icon where you drag and drop things you no longer require.

3 CD-ROM icon. The shaded nature of this icon tells you its contents are displayed.

4 The active window showing the contents of the CD-ROM.

5 Icon for the Zip disk.

6 Inactive window showing the contents of the Zip disk.

7 Inactive window showing the contents of the Adobe Photoshop 5.5 folder.

8 Iomega Guest icon. Double clicking loads the Zip disk onto the Mac desktop.

9 Shortcut icon for Explorer. Double clicking on the icon launches the application.

10 11 Application icons.

12 Folder icon.

13 The Apple Menu lets you quickly access controls, applications, and utilities.

14 The Control Strip gives you an easy way to change settings.

>>PERIPHERALS

Peripherals are additional devices for specialized input, output, and storage. The basic input device for an imaging workstation is a mouse, a pointing device that allows the user to navigate through and operate applications.

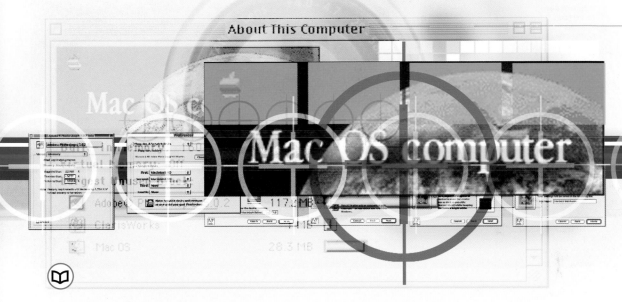

For precise drawing and art work, a graphics tablet and stylus may prove to be more natural for artists and designers to operate. The stylus is an electronic pen which is pressure-sensitive; it works in exactly the same way as a mouse, pointing and double-clicking to instigate commands, but is easier to use than a mouse for drawing smooth lines.

Other common peripherals are external hard drives, scanners, and printers. When several peripherals are connected to a computer, the rate at which the data is passed between them can have a marked effect on how fast you can work.

Peripherals have dedicated plugs that fit into corresponding sockets or ports on the rear of your computer. The transfer of data along a cable from a peripheral device to your computer varies according to the type of port being used. A serial or parallel port transfers data at a relatively slow speed. Faster systems, used for sending large packets of data, such as image files, benefit

from a quicker interface such as a SCSI (small computer systems interface; pronounced "scuzzy"). A computer with a SCSI card or socket can have up to six peripherals connected at one time, as long as the total length of cable does not exceed 20 feet. SCSI devices must be plugged in when the computer is turned off, or damage may result. SCSI connectors can have a number of different male and female plug configurations, so you should check the compatibility of your computer with any new device before buying it.

A Universal Serial Bus (USB) is a faster system designed to reduce peripheral incompatibility problems. USB devices can be plugged in while the computer is on, with up to 127 different peripherals attached through a network of interconnected hubs. For very fast data transfer rates, such as those required by professional digital cameras, when downloading large image files, a Firewire connection (also known as an IEEE 1394 port) will be necessary.

digital:photography:peripherals

Chapter 2:
>>>Software

>>ADOBE PHOTODELUXE

Adobe PhotoDeluxe is one of many imaging applications designed for domestic and non-professional use. Often included free with a scanner, printer, or digital camera, it shares many common features with Photoshop.

It is aimed at users who want to modify their images for a family album or school project, and either print to a desktop inkjet, or save to a home page on the Internet. Images can be acquired through a scanner, digital camera, or Photo CD.

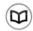

> The interface

The interface design is less complex than that of Photoshop, with bright button selectors rather than drop-down menus. The application is split into two sections, with a guided step-by-step or an "on your own" way of working. The guided section, complete with reminders, tips, and clues on what to do next, is useful if you have

little experience of navigating through a professional application. Guided tasks include basic contrast and color balance adjustment, removal of red-eye, and retouching through simple filters. There are also many fun filters and templates, for setting your photograph in basic card and calendar layouts.

PhotoDeluxe and Photoshop are very different applications that respectively give you less, or more, control of your imaging requirements. Similar to choosing between an automatic point and shoot and a professional SLR camera, you can choose to have varying levels of involvement in the image-making process. Ideal as a starting point or for less demanding users, PhotoDeluxe introduces all the basic concepts of image processing.

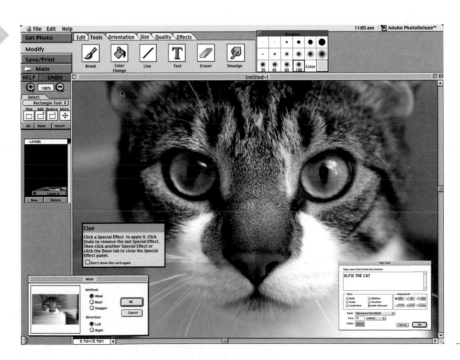

PhotoDeluxe user interface.

>> ADOBE PHOTOSHOP

Adobe Photoshop has become the industry standard application for digital photographers, but is also used by graphic, web, and multimedia professionals.

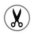

Not just concerned with providing a creative toolbox for image manipulation, Photoshop also allows the user to prepare highly specific output for print, web, and multimedia products. The new media revolution is bringing the traditional skills of photographer, graphic designer, code programmer, and video editor ever closer together. As these roles are constantly redefined, good Photoshop operators will always be highly valued.

For photographers, Photoshop allows the user to do all the usual darkroom processes such as cropping, enlarging, contrast adjustment, burning/dodging, and color correction. More advanced adjustments are possible too, with a zone-system type control of contrast, and a built-in densitometer to monitor the brightness range in the image. Camera effects can be mimicked too, and shallow depth of field, motion blur, and perspective distortion are easy to create. But Photoshop also allows the user to modify digital images in ways which are impossible with conventional photographic and reprographic processes.

New possibilities exist for the merging of many different source images, from film and print originals to scanned objects, textiles, and textures. Painting, drawing, blending, and merging can be added to the darkroom processes, together with a huge working color palette. The skills to operate this level of control can be developed over time and it is not necessary for the new user to climb a mountain before seeing some effective results. Highly complex functions stay in the background until you are ready to use them, and the program will not impose unnecessary restrictions on demanding users.

Other image manipulation software such as Adobe PhotoDeluxe only allows basic image control, so for serious users, Photoshop is the only option.

> Layers

Photoshop permits the use of layers when constructing an image, which are like individual overlay cells in an animation sequence. Different source images can be floated over each other and set down when ready. Keeping your image in layers also allows you to backtrack and make infinite alterations until the desired effect is achieved.

> Merging and swapping

Most image data in Photoshop is transferable from one image to another, and layers, selections, and carefully drawn shapes can be swapped back and forth between many different images.

> Settings

Many settings or recipes can be saved and stored away for future use on other images. Examples of these are contrast curves, toning color recipes, and color adjustments. Photoshop can therefore be customized by keen users who can build up a store of settings, much like keeping different developers, toners, and paper types in a darkroom.

> Upgrading

Photoshop is updated by Adobe, usually every 12–18 months and the upgrades are considerably cheaper than the full versions. New functions and integration with the latest web technological developments are the usual reasons for upgrades.

> Software plug-ins

Many third-party developers produce software plug-ins that add extra functions to Photoshop. Useful plug-ins are made by Extensis, such as Mask Pro, which simplifies the task of cutting out fringed shapes, and Intellihance, which gives a more extensive preview panel of the results of sharpening and other image adjustments.

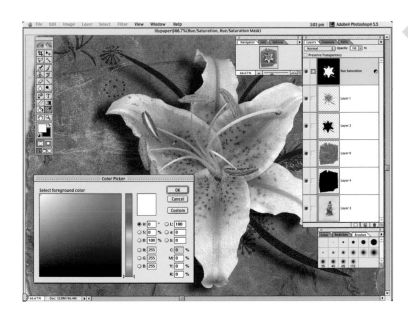

The color picker and the arrangement of layers for this complex montage project.

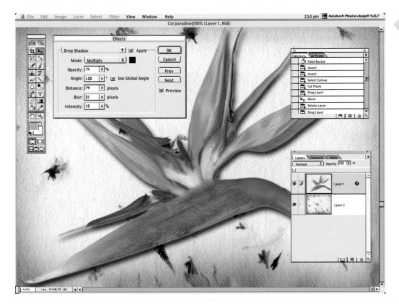

The working area in Photoshop together with the Layers and History palettes. A drop shadow effect is being applied to the flower on layer 1.

> Action files

Photoshop users can create simple programs that automate repetitive or time-consuming tasks, called "Actions." These sequences can be played over a batch or folder of images, creating identical results. An action file called "Contact Sheet" comes pre-loaded and pastes small versions of all the images in a folder into a new image window, to look like a conventional contact sheet. Action files can be saved and edited, and are frequently exchanged between keen users over the Internet.

> Web links

The web is the best place to keep up to date with your application. Minor upgrades, advice, and expert demonstrations are available freely via the Adobe web site on **www.adobe.com**. Many useful plug-ins are devised by users and distributed freely via user group networks.

digital:photography:adobe photoshop

1 2 3 4 5 6 7

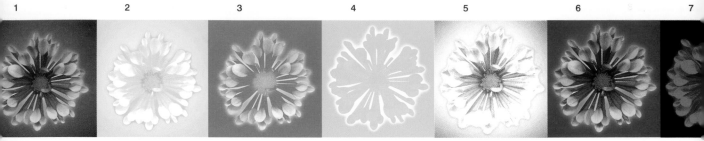

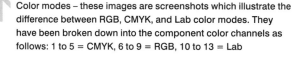

Color modes – these images are screenshots which illustrate the difference between RGB, CMYK, and Lab color modes. They have been broken down into the component color channels as follows: 1 to 5 = CMYK, 6 to 9 = RGB, 10 to 13 = Lab

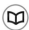

› Color modes in Photoshop

Images can be created in the Grayscale, RGB, or CMYK color space. In Photoshop it is possible to choose to work within each of these very distinct palettes, but only RGB gives you access to the full creative tools of the application. For users who will only output to a desktop printer, working in RGB is fine, and further consideration of CMYK is unnecessary.

RGB stands for Red, Green, and Blue. CMYK stands for Cyan, Magenta, Yellow, and Black (historically called the "key" color, hence K), and these are the standard inks used in the lithographic printing industry to reproduce color images. To create printing plates, photographic images are divided into four channels, with one for each ink color. The image is separated into minute dots called a halftone screen to enable the viewer to visibly mix the ink colors.

A CMYK-mode digital image is only simulated by the RGB monitor display, so the litho printed version will look different from the screen display. Working in CMYK means allocating an additional channel for the extra fourth color, and image data is increased by 25 percent. Working in CMYK mode also means accepting a reduction in Photoshop's creative capabilities, and certain blending effects will be unexpectedly odd. A better way of working is to use the CMYK Preview. With this option, you are still working in RGB, but the image simulates the appearance of a CMYK conversion, before the deed is done. Out-of-gamut colors can be previewed too, and given a false color to highlight their position, enabling corrective action before conversion takes place.

Lab color mode is a theoretical color space, unlike RGB and CMYK, both describing the actual color space of an output device. In Lab mode, color and brightness are split into three different channels, two for color and one for brightness. In Photoshop's channel palette, Lab is displayed with channel L for luminance or brightness, channel A for colors green to red, and channel B for yellow to blue. Lab mode can be useful where there is a need to adjust the brightness of an image, particularly in shadow areas, without affecting the color balance. Another useful technique is to apply unsharp masking to the lightness channel only, thereby avoiding the familiar color edge artifacts created by over-zealous use.

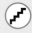

› Converting to other image modes

››› **Grayscale to RGB** If you want to colorize or add toning effects to a grayscale image (created by a palette of only 256 values), a mode change to RGB is necessary. This won't immediately change your image into a colored one, but it will allow you to draw on a new palette of 16.7 million colors. Unfortunately the file size will triple.

8 9 10 11 12 13

CMYK mode
1 CMYK composite
2 Cyan – cyan channel
3 Magenta – magenta channel
4 Yellow – yellow channel
5 Black – black channel

RGB mode
1 RGB composite
2 Red – red channel
3 Green – green channel
4 Blue – blue channel

Lab mode
1 Lab composite
2 Lightness – lightness channel
3 a – a channel
4 b – b channel

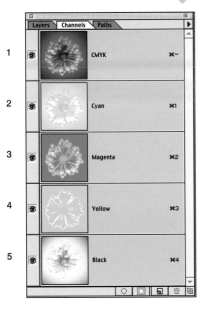

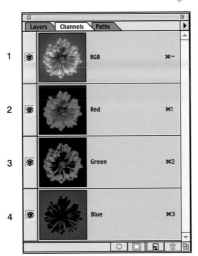

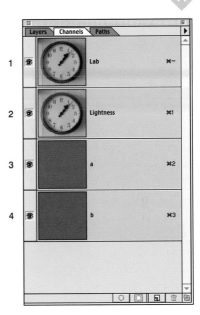

>>> **RGB to CMYK** CMYK mode is only necessary when you are preparing images for four-color litho output. As the CMYK color space is much smaller than RGB, you will notice certain colors becoming dull and murky when conversion takes place. The reproduction of bright greens and blues is poor in CMYK, so many users choose to work in RGB only, and leave the CMYK conversion to an experienced bureau operator instead.

>>> **RGB printed on a CMYK inkjet** RGB images are converted invisibly by the printer software to enable printing with the four or six ink colors. Depending on the device and the software, many good quality printers deal with this task remarkably well.

Chapter 3:
>>> Work space and workstations

>>THE WORK SPACE

Time spent setting up your imaging equipment in a suitable working environment is time well spent, and if space and budget permit, some minor modifications to your room can make all the difference.

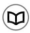

Positioning your equipment correctly is the first consideration. You should avoid placing the monitor opposite a window or near any brightly colored surfaces because of light reflections. The best option is to have your daylight softened through white roller blinds, together with dim ambient lighting. Excessive glare from the monitor screen will make your eyes work harder.

Eye strain is a common problem with IT workers, so users should avoid prolonged sessions as eyes can become accustomed to focusing at a set distance. It is wise to look away regularly and focus your eyes beyond the screen, if you are not able to get up and take a break.

Chairs are crucial, too, and standard lower back support is essential if you want to avoid back pain later on. Computer desks are deeper than standard tables and are this way for a reason: to give adequate space in front of your monitor to rest your wrists when not typing. The temptation is to use an existing piece of domestic furniture, but recent cases of repetitive strain injury (RSI) have occurred where little consideration was made for IT workers, with cramped and restricted working conditions.

Make sure your work area is large enough to enable you to adopt a relaxed position and to be able to change your position frequently.

Power supply also needs to be considered as your computer, printer, and peripherals will have independent power requirements which may exceed the normal load for a domestic socket. For environments subject to surges in power supply, it may be necessary to install a device to stabilize and moderate the current, as unexpected crashes can cause a catastrophic loss of data.

Electrical failure can occur in two forms: brown-out, when a slight drop in voltage can slow down a spinning hard disk, creating havoc if you are saving at the time; and black-out, which occurs when the power supply cuts out totally and unexpectedly. Installation of an uninterrupted power supply (UPS) can be useful if you want to insure against these occurrences. UPS systems create a back-up power reserve which gives you time to save and close down after the main power fails. The better the system, the more time it gives you to close down. Always take advice from a qualified electrician if in any doubt.

1. Keep the shoulders relaxed.
2. Make sure the forearms and hands are level.
3. Position the top of the screen at or slightly below eye level.
4. Make sure there is adequate support for the lower back.
5. Keep thighs straight.
6. Keep feet flat on the floor.
7. Make sure there is adequate clearance under the desk.
8. Position the screen to avoid light reflections.

18–28 inches

>>MONITOR CALIBRATION

The careful setting-up of a monitor is often overlooked by many users, who take standard factory settings for granted. The brightness and contrast controls of a monitor are the most basic way to change your display, but more precise control is offered by calibration software.

Color is reproduced differently from one monitor to the next, due to different phosphors used in the manufacturing process. This unique limitation is known as "color space," and the extent of this space is called a gamut. Since there are thousands of different monitors and printing devices, each having unique color spaces, keeping a level of consistency between them is virtually impossible.

To ensure that similar on-screen colors are recreated by your printing device, it is necessary to use a screen calibration program such as Adobe Gamma, which is included with Photoshop. This small program takes you through a step-by-step process and enables you to adjust your monitor's brightness and contrast correctly, and save the settings in an internationally recognized format, known as an ICC profile (International Color Consortium).

All Macs and most PCs have software which attempts to regulate the display of color, called the Color Management Module. CMMs commonly in use are Photoshop's own, Apple's Color Sync, and Kodak's Color Management System, usually part of Windows. These small applications read and interpret ICC profiles when opening image files and make the necessary adjustments, therefore attempting to retain some level of consistency throughout the system.

The best CMM to use is Adobe's own color management system which comes with Photoshop, since this is device-independent and creates a color space unique to Photoshop, rather than to the monitor you are using. The theory is that the color characteristics of your image will remain constant when viewed in Photoshop, on lots of different workstations. This working practice sounds fine in principle, but means that everyone must adopt the same rules, which in reality is no easy task.

A sequence of screenshots, showing the Adobe
Gamma screen calibration, Wizard.

1

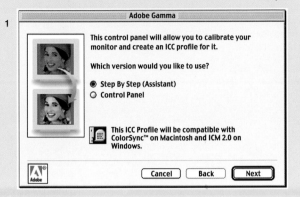

Adobe Gamma

This control panel will allow you to calibrate your
monitor and create an ICC profile for it.

Which version would you like to use?

● Step By Step (Assistant)
○ Control Panel

This ICC Profile will be compatible with
ColorSync™ on Macintosh and ICM 2.0 on
Windows.

Cancel Back Next

2

Adobe Gamma Assistant

The first step in calibrating your monitor is to
adjust the brightness and contrast controls to their
optimal settings.

◑ First, set the contrast control to its highest
setting.

☼ Then, adjust the brightness
control to make the center
box as dark as possible
(but not black) while keeping
the frame a bright white.

Cancel Back Next

3

Adobe Gamma Assistant

The red, green, and blue phosphors in a monitor can
vary from one manufacturer to the next.

Your current monitor profile indicates that your
monitor uses the following phosphors. If you know
this to be incorrect, please choose a different setting.

Phosphors: Custom... ▼

EBU/ITU
HDTV (CCIR 709)
NTSC (1953)
P22–EBU
SMPTE–C(CCIR 601–1)
Trinitron
✓ Custom...

Next

4

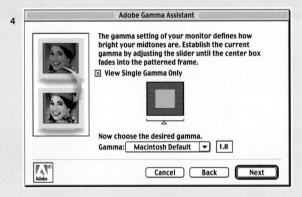

Adobe Gamma Assistant

The gamma setting of your monitor defines how
bright your midtones are. Establish the current
gamma by adjusting the slider until the center box
fades into the patterned frame.

☒ View Single Gamma Only

Now choose the desired gamma.
Gamma: Macintosh Default ▼ 1.8

Cancel Back Next

5

Adobe Gamma Assistant

You have now completed the Adobe Gamma Assistant.
To view your screen prior to these changes, compare
the results of the following options.

○ Before
● After

Your settings will be saved in the following file:
File Name: TIM DALY RGB Profile

Cancel Back Finish

> Warm-up

Most monitors need at least 30 minutes to warm up to reach a set level of illumination, and any calibration should not be carried out beforehand.

> ICC profiles

A profile is a list of characteristics that describes a particular color space such as an Apple 13-inch monitor. Profile definitions exist for most devices, or you can easily construct your own. The International Color Consortium was established by leading companies such as Apple, to enable common standards to be developed between manufacturers.

> Embedded profiles

The monitor ICC profile that is selected when you work on an image actually becomes part of your image data, and is embedded in the file. This data is then analyzed and acted on by a Color Management Module, when your image is viewed on a different monitor in a different workstation.

> Monitor controls

Once calibrated, the monitor's standard buttons for increasing contrast, brightness, and color should be left untouched. To avoid accidental adjustment, tape up dial controls or tape off panels altogether.

Comparing color palettes

The visible color gamut, which is the range the eye can see, includes many more colors than the RGB (red, green, blue) gamut used to display color on monitors. The gamuts of printed color depend on the printing process used. Custom color systems can reproduce more colors than the four-color process. HiFi Color has the largest printable gamut of all.

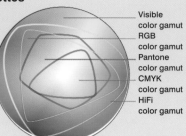

Visible color gamut
RGB color gamut
Pantone color gamut
CMYK color gamut
HiFi color gamut

Red **Green**

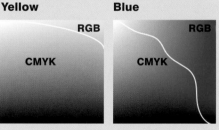

Yellow **Blue**

When colors are translated from the RGB gamut of the computer screen to the CMYK gamut of process printing inks, the CMYK range does a better job of reproducing some colors than it does with others. For example, more RGB greens than blues can be successfully reproduced with process inks.

Gamut alarms

Some programs include color management features that alert you when colors in your image fall outside the gamut of a particular output process. The reproduction (at right) shows a screenshot from Photoshop 3.0 with the gamut alarm turned on and the SWOP (coated) output profile chosen. The white dots show which parts of this RGB image contain colors that cannot be printed with the chosen (CMYK) process.

>> CONFIGURING YOUR WORKSTATION

When purchasing a computer for digital imaging, be wary of buying a system which does not allow the addition of extra memory, performance-enhancing cards, or a larger monitor.

Most computers are sold with a minimum amount of RAM, such as 32MB, which is enough to run the operating system and most non-professional applications at the same time. Extra slots to install additional memory chips are common, and the more empty slots you have, the more memory you can install. When using Photoshop, extra memory allows you to work both at speed and on higher-resolution images. With professional workstations it is not uncommon to find RAM in excess of 400MB.

When adding extra RAM to your computer, you need to order the right kind of RAM chip to fit. A SIMM (single inline memory module), is a common kind of RAM chip found in older machines. Nowadays this has been largely replaced by DIMMs (dual inline memory modules). The two types of chip are physically incompatible, as DIMMs have 168 pin connectors and SIMMs have 72 pin connectors. You can't install older SIMM chips in computers with DIMM slots. The model name of your computer will usually be enough information for a memory retailer to advise you on the most appropriate part.

Adobe Photoshop has been designed not only to allow users to create exciting visual images, but to use a computer's available memory and storage resources very efficiently. Most of this happens behind the scenes and it is not necessary to be conscious of this activity, only to

allocate the right resources to the application when setting up.

RAM is like a large cake that needs to be divided up between your different applications. Each application comes with a minimum memory requirement, clearly marked on the packaging. If less than this memory space is available, the application won't work on your computer. With Photoshop 5, the minimum requirement is 19MB of free RAM. Now considering that the operating system software could require an additional 16MB, taking the total to 35MB, it makes a machine with only 32MB of RAM impractical to work with. Therefore a minimum of 64MB should be seen as a starting point for an imaging workstation. When allocating memory to Photoshop, subtract the OS memory requirements from the total RAM and allocate the rest to Photoshop.

Photoshop cleverly utilizes memory resources to manage large amounts of image data by creating an area called a scratch disk. In reality, this is a portion of the hard drive (or other drive that you nominate) that is used to store less urgent information, leaving the quick access RAM area as free as possible. When the RAM area runs out, often during a complex filtering routine, Photoshop writes to the scratch disk. As this can take longer to read from and write to, it slows the process down.

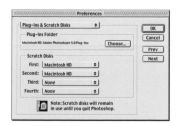

 Workstation configuration screenshots from Photoshop and the Mac OS to show how to allocate memory resources and scratch disks.

It is recommended that your RAM is five times greater than the largest image file you are likely to work with, as images and operations are swapped from RAM to disk throughout a session. If this is not within your budget, you can still create effective work, but it means accepting a slower pace of life.

Memory requirements are not the only aspect of a computer that can determine performance; the monitor, too, needs to be allocated enough resources in order to display the changing image data as soon as you make changes. In this case a video card or additional video RAM (VRAM) is needed to allow large quantities of data from the CPU to be displayed on the monitor without delay. When purchasing a monitor, the packaging may claim higher display capabilities than you thought achievable when connected to your computer, but the additional resources (and subsequent cost) needed to achieve these specifications are rarely mentioned.

> Efficient use of limited RAM resources

If you have limited RAM on your machine, keep your system software requirements to a minimum by moving all unneccessary fonts into a reserve folder, otherwise these add an extra burden on your system. Reducing the number of image files open at the same time also speeds up operations.

>>> Very large files
If you are still unable to filter images or perform other image adjustments on large image files because of a lack of memory, perform the task on individual channels one at a time.

>>> Other applications
When running Photoshop, close all other applications. Having desktop publishing (DTP) or other graphics programs open at the same time can be convenient, but they will take a share of the RAM away from your imaging application.

>>> History palette
Photoshop allows you to retrace your steps by using the History palette. You can set this to record up to a maximum of 100 previous commands, but as each of these previous commands is stored in the scratch disk, the performance is easily reduced. Keep your History limit to the last 30 steps, and reduce this figure as you get better.

>>> Image resolution
Perhaps the most obvious way to economize is to ensure that you are not working on an image file larger than it needs to be. A letter-size 300 dpi RGB is 24MB in size but falls to 10MB if the resolution is dropped to 200 dpi. Match your image resolution to the specifications of your output device as you won't see any difference in print quality if your image has a higher resolution than it needs.

>>> Clipboard
Some commands such as copying send large amounts of data to the clipboard on your scratch disk. You can still copy areas of one image to another image without using the clipboard, simply by dragging the selected area from one image window into another with the Move tool.

>>> Purge
Under Edit >Purge you can make a clean sweep of all the background data on your scratch disk. This is something like clearing your desk of all unneccessary and out-of-date paperwork.

>>> Virtual memory
On a Mac the virtual memory function is often used when limited RAM has been installed, and essentially does the same tasks as Photoshop's overflow scratch disk. Running the two overflow systems side by side will cause a drop in performance, so virtual memory is best left turned off.

Chapter 4:
>>> Digital images

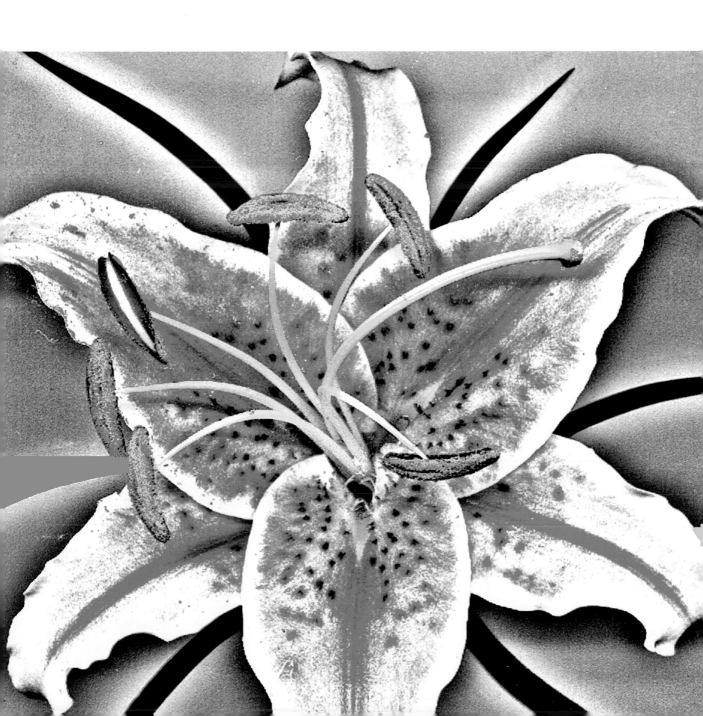

>>WHAT IS A DIGITAL IMAGE?

Humans assimilate art and music by the conversion of analog light and sound signals into minute electrical signals which are reconstructed by the brain. Analog signals are continuously variable in their description of color, brightness, or loudness.

Digital images result from the conversion of analog data into digital data by a process known as sampling. A digital image is a mosaic-like grid of picture elements known as pixels. Each pixel is created when a color and brightness measurement is taken from a given position, and recorded as a discrete number. This binary number holds the instructions for recreating this pixel with a specific brightness and color. Sampling, as it is known, refers to this measuring process and the greater the amount of sampling, the greater the quality.

> **Input**

To create digital images, the analog signals from many different originals such as film, print, and drawings, are converted into a digital code. When light with different brightness values hits the charged couple device (CCD) sensor it creates minutely different voltage values with different brightness values. These values are then converted into digital code by an analog-to-digital converter, known as an ADC. Once a digital image file is created, pixels can be adjusted and manipulated in a

Painting by numbers

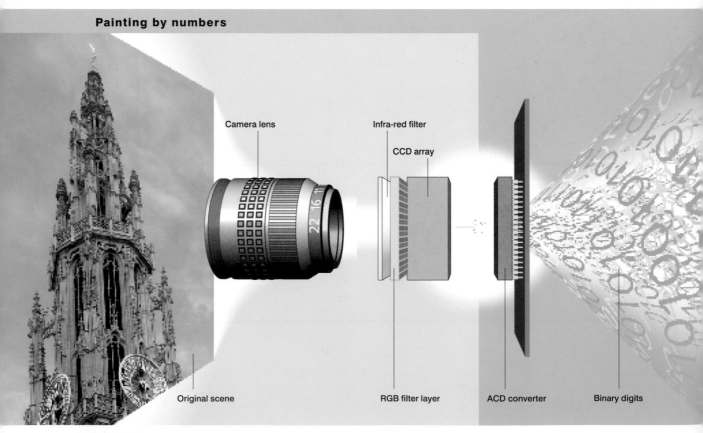

Camera lens

Infra-red filter

CCD array

Original scene RGB filter layer ACD converter Binary digits

Image © AGFA

This high resolution image has a pixel dimension of 1300 x 1300 pixels.

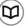

number of ways such as changing color, removing unwanted pixel areas, or joining two separate pixel grids to make a new image. Once a satisfactory image has been created, then it can be output to screen, print, or film.

> Resolution

Digital image resolution, unlike the resolving power of a camera lens, does not just refer to the quantity of visible detail, but also to the number of colors present. The quality of a digital image is therefore described by two independent measurements: first by the quantity of pixels, as in 640 x 480 pixels (sometimes referred to as pixel dimensions); and second, the number of colors, as in 24-bit color, which is sometimes referred to as color depth. All images are mixed from a finite number of colors, and the color depth of a digital image is best compared with an artist who uses a palette of few colors. An image can be created with different palettes ranging from only black and white (1 bit), to up to sixteen million colors (24 bit).

> Bitmaps

Pixels are mostly square in shape, and a grid of these individual units is called a bitmap; most digital images are therefore square or rectangular. The exact position of each pixel in the grid can be mapped using X (horizontal) and Y (vertical) coordinates, which give a specific "address" for each one.

> The black and white image

Black and white images (or grayscale, as they are known), are constructed from a limited palette of 256 tones, from black (0) to white (255). With so many intermediate levels of gray present, the human eye is unable to detect any sudden steps or banding. Each square pixel in a grayscale image has a brightness value somewhere between 0 and 255. Photo-realistic grayscale images must be a minimum of 8-bit, and data files of this type are only a third of the size of color RGB images.

digital:photography:what is a digital image?

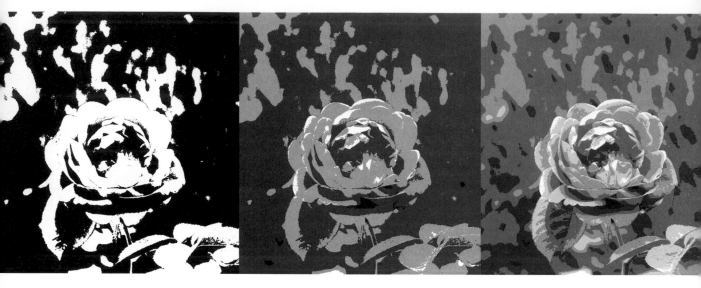

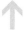 1-bit images are black and white only.

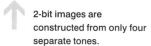 2-bit images are constructed from only four separate tones.

 3-bit images are compiled from a palette of eight colors or tones.

The RGB color image

Each separate pixel in a RGB color image derives its unique color value from a mixture of Red, Green, and Blue. Each of these colors, or channels, has a range from 0 to 255 brightness levels. One single colored pixel results from a recipe such as: R: 32 G: 56 B: 99. With so many combinations of these three color channels available, a 24-bit color image can be created from a palette of 16 million different colors.

> Common currency

A 24-bit RGB image is the common currency in digital imaging. Many capture devices can detect 30-, 36-, or even 48-bit color, but these must be reduced back to 24-bit for display, processing, and output.

> Binary numbers

Computers use the binary number system for representing standard decimal numbers. Unlike the decimal system, which uses ten individual digits, 0–9, the binary system uses only two: 0 and 1. Binary numbers consist of individual digits called bits and represent normal decimal numbers as follows:

For a 2-bit number using 0 and 1, only 4 decimal numbers can be represented:

00 (=0), 01 (=1), 10 (=2), 11 (=3).

If each binary number described a different tonal value, only four tones could be represented:

black, dark gray, light gray, white.

As an extra digit is introduced, so eight combinations are possible, therefore from a 3-bit number, eight tones can be produced, giving a step of eight tones.

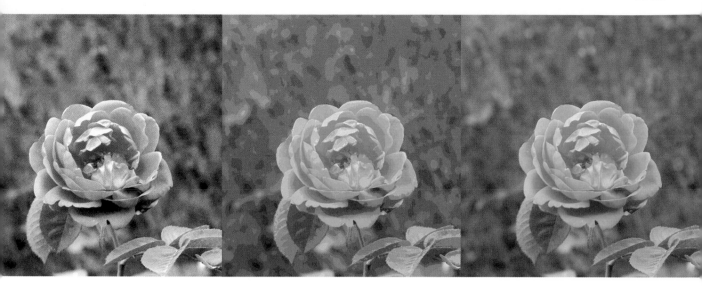

An 8-bit image is the most common palette for a grayscale image. The palette uses up to 256 steps from black to white. The human eye is unable to detect any sudden banding or jumps in an 8-bit grayscale.

Color images can be created in an 8-bit palette too. Sometimes called Index mode, these images are limited to 256 different colors. Unsuitable for the reproduction of subtle color, images become posterized, or broken down into crude color sections by this process. 256-color images have a small file size, commonly used for graphic panels on web pages.

24-bit is the common currency for color digital images. The photo-realistic image is created from a palette of 16.7 million colors.

Similarly:

for 4 bits = 16 tones;

for 8 bits = 256 tones.

RGB color images are 8 bits per color, or 24 bits in total. This allows each pixel to be recreated from a number recipe of R256 x G256 x B256, or a palette of 16.7 million colors.

An 8-bit number such as 00001111 + 00001111 + 00001111 = the color recipe of one single RGB pixel.

The computer is a collection of millions of connecting switches which turn on and off as they process binary number calculations. Data is transferred from the processor to the monitor, and 24-bit binary numbers are used like a recipe to display each colored pixel of an image. Each binary number holds the code for recreating a pixel of a certain color or tone and in digital imaging, the bigger the bit-number, the greater the color palette.

Data size

8 bits = 1 byte

1,024 bytes = 1 kilobyte (K)

1,024 kilobytes = 1 megabyte (MB)

1,024 megabytes = 1 gigabyte (GB)

In a simple word processed document, there are less than 256 different characters and punctuation marks, so each separate page element can be described by an 8-bit number. One element in a word processed document takes up one byte of data, and a typical letter-size page may consist of 2,000 separate elements, but will only be 2K in data size.

Since the binary code for a single 24-bit color pixel, in a grid of potentially millions of picture elements, is a longer number than one needed for a letter character, it is easy to see why image files are considerably larger than text files.

digital:photography:what is a digital image?

>>ACQUIRING IMAGES

>Photo CD

A very cost-effective way to acquire digital images is to have a Photo CD made from your film originals. Developed by Kodak, this service is available over the counter in photographic processing stores. Your negatives or slides, which can be a mixture of both black and white and color, are sent by these shops to Kodak, who scan and write them to a CD. This disc can contain up to 100 high-quality digital images, and is returned with an index print, showing a small thumbnail of each image on the disc. Extra images can be added to the same disc at a later date and the whole process is available at a very low cost. The advantage of this system is that the scanning and disc-writing is done professionally, and you don't have the outlay of a film scanner or a CD writer.

The Photo CD therefore acts as a digital storage file, and can be useful for archiving large quantities of images. The discs can be read in a normal CD drive on both Mac and PC platforms, or viewed on a television via a Photo CD player.

Apart from the economic advantage, a Photo CD has a unique kind of file format where the image is saved in five different versions, from an 18MB high resolution version, suitable for print output, to a 70K low resolution version, suitable for browsing. This hierarchical system of files, called an image pac, uses common data and Kodak's own compression routine, to create the five separate resolutions. A professional version is available too, called Pro Photo CD, where medium and large format film can be scanned at a higher cost, but still much cheaper than drum scans from a professional scanning bureau.

Opening the files on a disc, however, is not entirely straightforward, and users will need to ensure that they do not open and print low-resolution files by mistake. As Photo CD discs are read only, users will not be able to write any changes to the CD, or to the hard disk using the Photo CD format.

>Picture CD

Picture CD is a similar CD-based package from Kodak, aimed at the domestic market. This service is usually available as an extra only when submitting film for processing and printing, and is half the price of a Photo CD service. Image size is smaller at 1024 x 1536 pixels or 4.5MB per image, and images are saved as JPEG files. (File types are covered in Chapter 6.) Free software is included on the CD to allow very basic manipulation.

>CD-ROM

Many companies and photographic libraries make considerable sales from CD-ROM discs of copyright-free images. These discs can vary in price considerably, depending on their purpose. Colored studio-type backgrounds and textured surfaces, useful for inclusion in montage work, are at the lower end of the scale while

PhotoDisc is a large company that specializes in the sale of royalty-free stock photography. They sell subject specific CD-ROMs of high quality image files, suitable for print reproduction. Unlike a conventional picture library that charges for each separate image, PhotoDisc CD-ROMs are royalty free, once a disc has been purchased. Visit the site on **www.photodisc.com**.

generic stock photography of business people is at the top end. Most discs contain high-resolution images in common file formats such as TIFF or JPEG, which are accepted by all major imaging applications.

> ## The Internet

Acquiring images over the Internet is fast becoming a quick and efficient way to work. A variety of sites exists offering an enormous amount of images, with many photo libraries going online with searchable image databases. Copyright-free images are useful for pasting-up page layouts for client presentation or school projects, where high-quality printing is unnecessary. With the increase in data transmission speed that an ISDN line allows, high-resolution images can be downloaded from the library's server to your workstation in a few minutes, removing the expense of searching, packing, and delivery, and the inevitable delays.

> ## Web sites to consider

Always check the licensing and copyright notices before downloading images from commercial web sites. Rights to use images freely are often only granted for specific purposes, and usually don't permit commercial reproduction or resale.

The Corbis web site offers a huge number of images for many different purposes, such as screensavers or e-mail postcards. The site offers the user a search facility through a vast on-line catalog of photographs and illustrations. The site can be found on **www.corbis.com**.

Stockbyte are another on-line picture library that offer low resolution images freely for comping and paste-up. After a simple registration, users can access a vast number of photographic images. Stockbyte can be found on **www. stockbyte.com**.

digital:photography:acquiring images

Chapter 5:
>>> Digital cameras and scanners

>>HOW DIGITAL CAPTURE SYSTEMS WORK

Digital scanners and cameras both use a light sensor called a charge-coupled device or CCD.

Cameras are defined by the number of pixels that the CCD can create, and models are commonly referred to as megapixel cameras (over a million) or more usefully by the pixel dimensions of the maximum image created, e.g. 3500 x 2200 pixels. The CCD occupies the same position in a digital camera as film does in a conventional camera. The CCD is a matrix or grid of receptor cells ("photosites"), each responsible for the creation of a separate pixel.

>The photosite

A photosite is like a minute container filled with light during exposure. The quantity of light that fills the container creates a charge of greater or lesser intensity. It is the size of this charge which is translated by the analog-to-digital converter into a pixel of a specific brightness and color value. Shutter speeds and aperture combinations are used to set the quantity of exposure according to the CCD's ISO sensitivity. When light levels are low, a slower shutter speed allows enough light to fill the photosite container. When the containers are fully charged, white is created.

>Camera over- and under-exposure

Like the silver halide crystals in conventional film, the photosites in a CCD respond peculiarly to both over- and under-exposure. When light intensity is too great, the photosite containers overflow and fill adjacent containers, causing an effect called blooming. Blooming looks like a white fringe or flared edge, particularly noticeable around very bright highlights. When little light is present during long exposures in low-light conditions, an unwanted charge called noise occurs. Noise is characterized by random pixels of unusually bright colors.

>Aliasing and moiré

In front of the camera CCD is a small filter which removes unwanted infra-red light and softens the image to prevent aliasing and moiré effects. Aliasing occurs when a curved

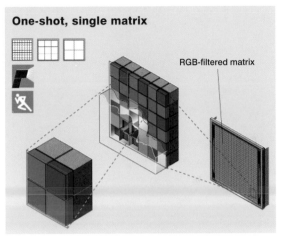

One-shot, single matrix

RGB-filtered matrix

Image © AGFA

line in a subject creates a staircase of square pixels in a bitmapped image. Digital camera images are deliberately soft to avoid this problem and to enable the user to assign sharpness at a later stage. Moiré patterns are created when a subject's fine pattern or texture creates an interference pattern with the pixels of a digital image.

>Sharpness

Sharpening an image with software is like focusing an enlarger before making a print. Photoshop is the best place to do this using the Unsharp Mask filter. Excessive sharpening can cause relief-like edges to occur together with an overall increase in contrast. See page 73.

>ISO

ISO (International Standards Organization) is the standard way to describe the sensitivity of conventional silver-based film. Digital cameras are sold with an indication of the CCD's ISO equivalent sensitivity. Yet unlike most film, a CCD may work within a range such as 200–800 ISO. Like film, CCDs will produce finer images at their lowest ISO setting. An increase in effective ISO speed is required at low-light situations when a much smaller charge, produced by the photosite, needs to be amplified.

>>PROFESSIONAL SLR-TYPE DIGITAL CAMERAS

Professional SLR-type digital cameras have developed quickly in recent years, and with prices dropping and specifications rising, new models will soon fall within the budgets of most professional and keen amateur photographers.

SLR digital cameras are commonly built around the Nikon or Canon systems, which are familiar to most photographers, and they can be used with the existing series of professional lenses. The cameras are operated in an identical way to film cameras, using shutter speed and aperture combinations to achieve correct exposures on manual, automatic, or program modes. The only difference is the CCD instead of the film.

The CCD sensors produce images of 2.5–6 million pixels, creating files from 6 to 18MB in size, easily good enough to make a photo-realistic, 8 x 10 print, and edging ever closer to full-page magazine reproduction quality. Recent cameras capture images with a quality previously only available from large matrix CCD backs, for medium-format cameras.

The storage of these images is by direct connection to your computer's hard drive in the studio or through removable PCMCIA or PC cards, slotted into the camera body. Inside the slim card pack of PCMCIA card is a mini hard disk which can store up to 230MB of data, or about 38 x 6MB images. These cards have become the standard professional removable media.

Good cameras from Nikon and Kodak have built-in LCD preview screens, usually on the back of the camera body. This lets you view the images just captured, and gives immediate reassurance that everything is working smoothly. With the better models, a histogram can be displayed too, letting you check your images are not over- or under-exposed. For the very first time, location photographers can view a day's shoot immediately, and are equipped with precise information at the time it is needed most.

ISO or film speed describes the sensitivity of the CCD, and many digital cameras can be used within a range such as 100–800 ISO. This is different from film ISO, which is usually described as a single value, such as Fujicolor 400 ISO film. This sensitive range of a CCD is best compared to the push-processing capability of normal film. Exposure at a faster ISO speed is possible, but the best image quality is achieved with the lowest ISO setting. Cameras with a more sensitive CCD, such as those with a range of 800–1600, are available and are particularly suitable for sports photographers and photojournalists. The issue of sensitivity can also be extended to dynamic range, and recent CCD sensors can capture a wider dynamic range than even negative film. As instant positives are created once downloading takes place, the reasons for continuing to use narrow latitude color transparency film are rapidly diminishing.

The ability to shoot in rapid succession with a digital camera is not governed by the use of a motor wind, as in conventional cameras, but by the ability to hold data in store before writing to the memory card. This is called burst rate and indicates how many frames can be stored in a buffer. The Kodak DCS 660 has a burst rate of 3, at 1 image per second, before writing to the PC card.

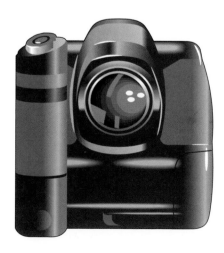

A professional SLR-type digital camera.

Color temperature is an issue normally dealt with by professional photographers through the use of lens filters and balanced film stock. With digital cameras, however, a white balance function allows the user to counteract the effects of fluorescent and other non-continuous light sources, at the point of capture.

The major drawback with these cameras, apart from high cost, is that the CCD sensor is smaller than a 35mm film frame. Although conventional lenses can be used, their focal length is lengthened and this increase is usually expressed by a conversion factor such as 1.2. This is most apparent when shooting on location using 24mm or 28mm wide-angle lenses, creating a smaller angle of view than normal. One solution would be for lens manufacturers to make wider lenses, but at a more realistic price.

To get the most out of your investment and to achieve satisfactory results, a good understanding of both sharpening and contrast manipulation is necessary or results may be disappointing, even from high specification systems.

> Over- and under-exposure

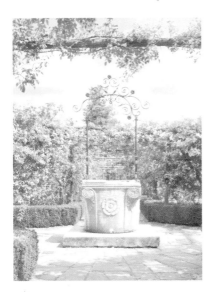

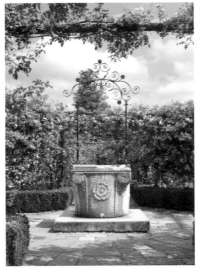

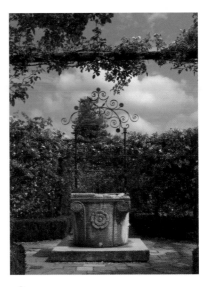

An over-exposed image showing excessive highlights and little shadow detail.

A balanced exposure, showing a good range of mid-tones together with highlight and shadow areas.

The under-exposed image, showing excessive shadow area and little highlight detail.

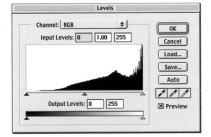

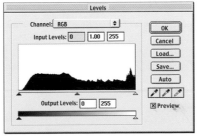

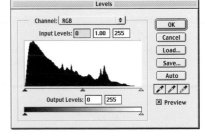

Photoshop histogram of the over-exposed image, showing burnt-out highlights and little shadow area. The resulting image will look like an over-exposed transparency.

This histogram shows a good distribution of captured detail in both shadow and highlight areas.

A large shift to the shadow areas indicates that most of the captured data is beyond the midtone and lies in the shadow areas. Resulting image will look like an under-exposed transparency.

digital:photography:professional slr-type digital cameras

>> POINT–AND–SHOOT DIGITAL CAMERAS

The mid-price digital camera has a sensor that can create an image in excess of one million pixels.

Megapixel cameras can produce a photo-quality inkjet print up to 5 x 7 inches, and most non-photographers would not detect its digital origin. However, for most photographers, the print quality would be noticeably poorer than the results from 35mm negative film, shot with a non-digital camera.

Although perfect for preparing image files for monitor display or the Internet, the professional photographic application of these cameras is limited to jobs where speed and minimum cost are the main concern. For many other purposes, non-photographic quality is perfectly acceptable. For artists and designers, these cameras are a much more cost-effective and convenient way to make sketchbook, record, or reference images instead of using instant film cameras.

Image data is saved and stored on removable memory cards, available in a number of capacities from 5MB to 40MB. Having extra memory cards is useful if shooting on location, or over a period of time spent away from your computer workstation.

The quantity and quality of images is dictated by the compression preferences chosen for saving and storing. Normally both TIFF and JPEG files can be created, with the low-quality settings using a lossy JPEG routine. On a typical camera with a 40MB image memory card, the number of available frames is as follows:

File format	no. of images
uncompressed TIFF	16
1/4 compressed JPEG	60
1/8 compressed JPEG	124
1/16 compressed JPEG	243

For maximum quality uncompressed TIFF is the best choice, but by doing this, you'll only be able to save a few

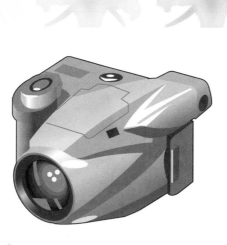

A point-and-shoot digital camera with a zoom lens.

A point-and-shoot digital camera with a large LCD preview screen for "live" coverage of your framing.

images before you reach full storage capacity. Certain models also let you apply a sharpening filter automatically to each image, but it's best to leave this off or on low, to avoid contrasty sharp edges on your prints.

Better models have a small LCD screen for the preview or playback of images stored on the removable card, as well as "live" coverage of your framing and composition attempts. You can connect to your PC using a camera-to-computer cable, a card caddy that fits into a 3.5-inch floppy disk drive, or a card reader with a SCSI interface. For quicker access on a laptop, an internal card reader can be fitted.

Many cameras have a direct-to-printer cable, enabling prints to be made without the need of a computer, which is useful on location or away from the office. Image quality will be basic; the primary adjustments of contrast and sharpening in Photoshop will yield much better results. Certain desktop inkjet printers, too, have a memory card slot, enabling prints to be run off the card, without the need for a camera connector.

Image files are sometimes saved in unusual or native file formats such as FlashPix, which can only be opened or uncompressed with software supplied with the camera. To enable data to be fed into a PC or a Mac, many input

devices such as digital cameras have a Twain interface. Twain is a set of standards devised by leading manufacturers (and bizarrely stands for Toolkit Without A Name) that enables the acquisition of images from external devices. Photoshop supports Twain-compliant devices, and the Twain interface looks much like a control panel showing small thumbnail images, like a contact sheet. Once selected, images can be manipulated in Photoshop and saved in a standard image file format such as PSD (Photoshop document).

Most of these cameras are based on an uncoupled range-finder system, with the user viewing the subject through a small window above or to the side of the lens. This is fine for most shooting purposes, but when close-up focusing is attempted, parallax error may occur.

The specifications and cost of these cameras rise with the addition of a zoom lens, stronger flash, and aperture/shutter speed selectors. Be wary of digital

A point-and-shoot digital camera with a standard LCD preview screen fitted to the back.

zooms, as this term does not relate to an increased focal length of the lens, but to a software enlargement (interpolation) of an image's central grid of pixels, making the subject appear larger, but without additional fine detail.

>> DIGITAL CAPTURE BACKS FOR MEDIUM- AND LARGE-FORMAT CAMERAS

CCD capture backs are available to fit most professional medium- and large-format camera systems. The cost of these units is high and usually within the budget of only well established commercial photographers.

For busy studios whose annual overheads include a considerable amount for film, processing, and delivery services, a digital capture back can save a small fortune. Competitiveness, too, is enhanced, with photographers able to turn jobs around faster, without the need for proofing materials and laboratory services. The versatility of digital image data means that photographers can give their clients direct CMYK-converted images, cutting their production time. Photographers can also convert image data easily for the client, into the most useful sizes or file formats, for page layout, or web design. The sensors themselves are versatile and many CCDs are able to detect a brightness range of twelve stops, even more than color negative film, and twice the range of color transparency.

The sensors fall into two categories: linear array, sometimes called a scanning back, and a matrix array. Like the sensor in a flatbed scanner, the linear array capture back has a thin strip of RGB photosites which detects light when moving slowly across the film plane. The obvious disadvantage of this device is that it needs to be securely mounted on a tripod, and it can't capture moving subjects.

Manufacturers of sensors for medium format cameras use a standard size CCD housed in a unit similar to a standard film back. This fits onto the back of professional cameras such as Hasselblad, Mamiya, and Sinar, using an adaptor mount, so that the same sensor can be used on different cameras. The image size produced by these sensors ranges from 25–30MB per image.

The best quality sensors are designed to fit onto 4 x 5-inch view cameras only, and have a much larger sensitive area. Image size can be in excess of 100MB, good enough to create 16 x 20–inch full color repro output. The CCD is housed in a holder, similar to one used by Polaroid proofing material, and precision software is often included to control highlight/shadow, color balance, and sharpening.

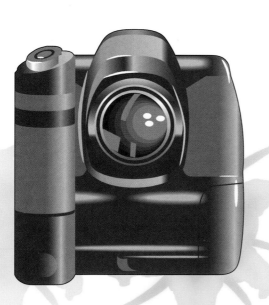

↑ A medium-format camera with a digital back.

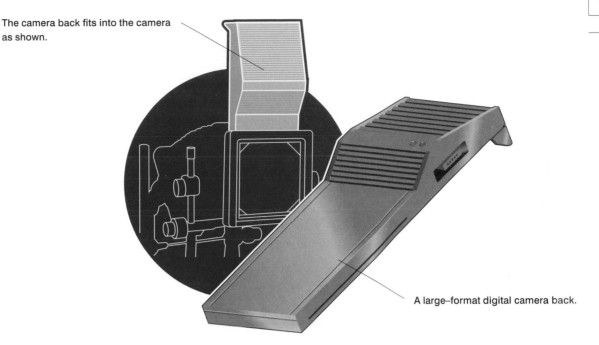

The camera back fits into the camera as shown.

A large–format digital camera back.

>>> Light sources
Non-linear array backs can be used with daylight and all standard photographic lighting such as strobe, tungsten, HMI, and fluorescents. Linear backs need continuous lighting, together with a stationary subject. CCDs do not respond well to very warm environments so care should be taken to shield the cameras from hot tungsten lighting.

>>> Cable length
Digital capture backs need to be connected to a computer in order to save and store large image files. The length of cable, therefore, is vital if photographers need the flexibility to move around, when shooting a model, for example. A sturdy computer table on wheels becomes a necessity too, when moving between sets.

>>> On location
It is possible to shoot on location if a power supply is available nearby and the capture back can be connected to a laptop for preview, saving, and storing.

>>> CCD size and lens focal length
Despite the large image files produced, the size of the capture CCD will be smaller than the normal film diagonal. Lens focal lengths will be reduced and problems may occur when wide-angle lenses are needed to get in close, or shoot in confined spaces.

>>> Interpolated image size
As with flatbed scanners, the image size of certain digital capture backs is described as an interpolated value. More precise indicators are sometimes referred to as "true color" image size.

>>> High cost
Matrix arrays are more expensive than linear devices, as there is a high rate of failure during the complex manufacturing process.

digital:photography:digital capture backs

>> FILM SCANNERS

The cost of film scanners has dropped drastically over the last few years, to a price no greater than that of a good quality camera lens. These devices are best bought as separate units, rather than add-on transparency hoods for flatbed scanners, as the quality will be much better.

Since original film material is much smaller than printed matter, the film scanner CCD sensor needs to have more photosites per inch than a flatbed sensor. A good 35mm film scanner will create a digital file good enough for a full page magazine reproduction, and up to an 11 x 17-inches inkjet print without any noticeable pixelation. Shooting conventional film and scanning in this way will give you better image quality than all but the most expensive professional digital cameras, and at a much lower cost.

The scanner is attached to your computer through a SCSI, USB, or parallel port interface, and the better models come with software that works within Adobe Photoshop. Known as a "plug-in," this allows you to operate the scanner and work seamlessly within your imaging application.

Film scanners are designed with a linear array CCD, a strip of light-sensitive cells that moves on a tracking rod over the film surface. These sensors are arranged in three lines with one each for red, green, and blue, and detect light transmitted through the film. The performance of a film scanner is measured in several ways but the primary consideration is optical resolution. This specification can be described as the linear CCD strip's 2330 pixels per inch, or the effective scanning area of the film, such as 2330 x 3500 pixels, or as the total pixels created, such as 8 million pixels, all essentially different descriptions of the same measurement. The higher the numbers, the better the quality, and most are capable of extracting 20–30MB of data from a single 35mm color film original.

The second consideration is bit depth or color depth, and this will give you an indication of the scanner's ability to detect subtle colors. Most devices are at least 30-bit and the better ones 36-bit. The higher the value, the more colors your scanner can detect from your film original.

Photographic film is able to record brightness over a limited range. Color transparency is able to record detail

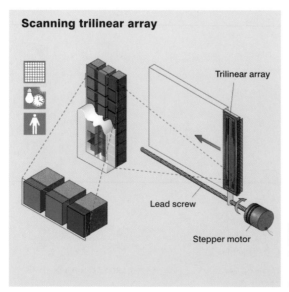

Image © AGFA

A film scanner.

> Scanning a color transparency

A typical control panel for the Minolta Dimage Scan Dual film scanner. Film types can be set togther with capture resolution (2438 dpi). The final pixel dimension of the scanned image is 2320 x 3504 and 23.2MB in size.

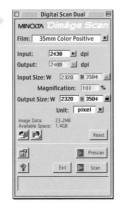

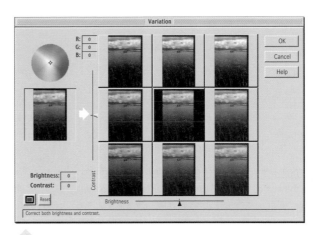

A varations window can allow the user to preview different brightness and contrast combinations, before scanning takes place.

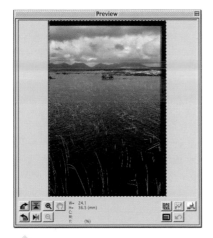

A typical preview window showing the image to be captured, and the black edge of the transparency film.

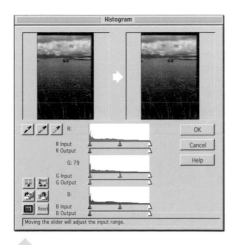

The histogram for each color enables precision capture control.

The scanned image, after Levels, Curves, and Color Balance adjustments have been applied in Photoshop.

both in highlight and in shadow areas, across a six-stop range. In strong sunlight, however, where this range is exceeded, dense black shadows and clear white highlights are created when the film is developed. Negative film is able to record a nine-stop range, but the lithographic print process only five. The dynamic range of your scanner is a major consideration and describes the scanner's ability to capture the full brightness range of your originals. The density of film shadow areas is measured in "d" (also known as "Dmax"), on a scale of 0–4.0. Higher than 3.0d will capture most normally exposed film originals. Most difficulties occur when scanning the shadow areas of film originals, and film scanners that can record densities of 3.0d will capture all image detail from normally exposed film originals.

Scanner software is a major consideration and the better models have an easy user interface allowing quick and quality capture, with more precise controls available in the background if needed.

Better film scanners are manufactured by the leading camera companies, and there is little difference in quality between the mid-price units. Most are supplied with removable film holders for both negatives cut into strips, mounted transparencies, and APS film.

Purchasing considerations

Buy the best scanner that you can afford as the difference in quality will be very evident. The higher the quality, the bigger the print you can make from your digital file.

>>> Resolution

Look for the highest value you can find with optical resolutions above 2500 and a minimum color depth of 30-bit – 36-bit is even better.

>>> Software

Although not essential, your scanning software should work as a Photoshop "plug-in" and have useful additional functions such as Unsharp masking.

>>> Film holder

Check that the film holder is sturdy and able to withstand repeated use; as many manufacturers have paid little attention to this detail. Avoid tricky holders with difficult loading mechanisms since these could easily damage your original film.

>>> Shooting to scan

Transparency film is much harder to scan than negative film, as the limited brightness range often results in dense shadow areas, which scanners find difficult to handle. Negative film can record light over a greater brightness range and has less dense shadows, so the scanner can pull out shadow detail without difficulty. Shooting on color negative film is easily the best option, as positives are made instantly, and black and white versions can easily be made.

>>> Typical specifications for a good film scanner:

- Image sensor 3-line color CCD
- Optical resolution 2438 dpi
- Effective scanning area 2336 x 3505 pixels
- Color depth 30-bit per RGB

>>FLATBED SCANNERS

Flatbed scanners use a similar type of linear CCD as a film scanner, but a much larger version and the full width of the platen.

Flatbeds are best used for capturing opaque art work such as photographic prints and printed matter, but can also be adapted to detect three-dimensional objects. The units are mostly 8.5 x 11.7 inches in size with larger 11.7 x 16.5-inch versions for graphics and publishing professionals.

Flatbed scanners are usually attached to the computer by a SCSI, USB, or parallel port, and have software that works within Photoshop. The scanner has both a light source and a linear CCD sensor fixed to a screw thread tracking rod, that travels underneath the artwork, illuminating and detecting reflected light in one single pass.

Good scanners can cope with the variable density and dynamic range of photographic print originals, and good quality scanning is concerned with minimizing gain in contrast from the original artwork to the digital file.

The glass bed or platen of the scanner is constructed from high-quality material and is easily damaged; take care that no abrasive materials are placed in contact as the cost of glass replacement may be expensive.

The following types of original can be scanned:
- photographic prints, in color and black and white
- paintings and drawings
- magazine and newspaper illustrations
- typed or word-processed print-outs
- shallow three-dimensional objects

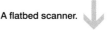

A flatbed scanner.

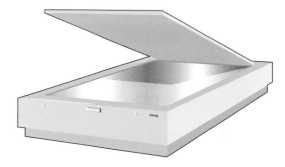

> **Purchasing considerations**
Good quality scanners are available at a very low cost, but go for a brand that has other models in the professional range, since the software may be common to both ranges and could contain useful filters and more precise controls.

>>> **Bit depth**
Bit depth is another term for capture color palette, and scanners that can convert an original print into a 24-bit digital image will use a palette of 16 million colors. Most scanners will be a minimum of 24-bit.

>>> **Optical resolution**
Beware of extravagant claims on the packaging, since very high resolution such as 4800 dpi will be an interpolated value. The optical value will give you a true idea of the specifications, and a 600 dpi device is adequate for most purposes.

>>> **Bundles**
Many scanners are bundled with full versions of Photoshop included in the price, which can cut down your start-up costs considerably. Some scanners come with optical character recognition (OCR) software that enables editable text files to be created from printed manuscripts, and this can be useful if no disk version exists. Other bundled software can enable the scanner to double as a rather expensive xerox machine.

>> SCANNING BASICS

Have your target output device in mind before scanning starts, since this will avoid confusing calculations about scaling factors, as well as input and output calculations.

The maximum capture resolution of a scanner determines the pixel dimensions of an image when created. There will be an upper limit to this figure, with 35mm film scanners typically 2400 dpi (but only over a 24mm wide film original), or 600 dpi for flatbeds (but this time over a 210mm wide platen). Match your input resolution to your target printer. Creating excessive files is like shooting a children's party on 4 x 5-inch film: you'll end up with more information than you really need.

> Enlarging and reducing

If you are working with very small originals such as 4 x 6-inch prints, it is worth bearing in mind that more than 200 dpi of detail does not exist in photographic prints. Enlarging a print by sampling or scanning at a high resolution will certainly produce a bigger pixel grid, enabling an enlarged print to be made, but it won't increase the quantity of visible detail. As with using a xerox machine, you can make your original bigger, but at the cost of sharpness. Scan the largest print original possible, or the negative if available.

> Matching your printer resolution

When manufacturers describe the output resolution of inkjet printers, very high values are quoted, such as 720 or 1440 dpi. This figure does not refer to minute individual ink dots separated by white space, but instead refers to the total quantity of dots that can be dropped in any one area. Ink needs to be mixed to achieve the required color, and this is done by dropping dots on top of each other. If a printer uses six colors, the dpi should be divided by six to get a better idea of the true resolution, so 1440 dpi essentially becomes 240 dpi. No advantage is gained in printing an image file with a spatial resolution in excess of this value. Please refer to page 144.

> Thinking in data size

Another way to minimize the mathematics at this stage is to look at the file size created by the scanning process. A 24MB 24-bit RGB image will be good enough to make an 8.5 x 11-inch sized image at 300 dpi on a high-quality device such as a dye sublimation printer. For an inkjet this can be reduced to 200 dpi or 11MB. For grayscale images, 8MB and 4MB file sizes will give equally good results. The data size is another indication of how many original pixels are present in a digital image.

Many scanners are sold with the ability to capture in 36- or even 48-bit color. These super-sampling devices allow the detection of very delicate color and tonal areas in original artwork. But for most image applications this enormous palette of billions of colors will need to be reduced or converted back to 24-bit color, or 8 bits per channel.

The key to scanning is to maintain the full brightness range of the original artwork or film. Poor scanning occurs when a gain in contrast is evident in the digital file.

> Image capture modes

Image capture modes are equivalent to different types of film such as color, black and white, or lith, to capture different situations. Grayscale mode is used for continuous tone black and white prints, RGB mode for color prints, and Lineart mode for drawings or diagrams.

> Halftones

Black and white images that have been printed in a newspaper or magazine are constructed with a grid of small dots called halftones. Use the halftone capture mode, and the scanning software will try and recreate a grayscale image from the dotted original.

A good example of a grayscale scan showing no gain in highlight or shadow areas

> Color originals from magazines

Some of the better scanners have a built-in descreen filter, which smooths out the effects of the four-color dots of the lithographic printing process. A drop in sharpness will occur as a consequence, but this can be rectified using an unsharp mask. Scan as RGB Color mode and apply the Unsharp filter in Photoshop.

> Lineart

Some originals, such as drawings or prints, will be plain black and white, and a Lineart scan creates an image like a high-contrast lith positive. Lineart scans need to be captured at a much higher input resolution in order to avoid aliasing occurring. This staircasing of pixel blocks is much more visible on Lineart images, due to the contrasting black and white tones. Scan your originals at 600 dpi if possible. When they're opened in Photoshop, they become images in Bitmap Mode. Working in this mode is extremely limited and you will notice many of Photoshop's functions are dimmed. Change to Grayscale or RGB to add tone and color.

> 256 colors

Some scanners allow the user to capture in a reduced palette of 256 colors. Blocky and posterized images are created, with very small file sizes, suitable for web and online distribution only.

> Scaling factors for reproduction

When preparing images for lithographic reproduction, color images need to be created at 300 dpi and grayscale at 150–180 dpi. These figures are higher than the 80 lines per inch and 133 lines per inch of the printer's halftone screens, but the reason is they need to have two pixels of image data to every single dot on a halftone screen. Scaling factors can vary, but are usually by a factor of two. In practice this figure can drop slightly. If enormous files create a storage and transport problem, consult your professional bureau or litho printer for advice.

>>SCANNING TECHNIQUES

Scanning a photographic print is much the same process as exposing film in the camera, and is a good starting point for beginners. In order to capture a faithful version of an original print, you'll need to ensure that the full tonal or brightness range survives this conversion process.

Badly scanned images show a growth in highlight and shadow areas with an inevitable loss of image detail. As with processing black and white film, it is best to aim for a slightly low-contrast result, with visible detail in both highlights and shadows. Bad scans are like under-exposed negatives: you may be able to rescue the contrast, but you won't be able to restore detail to the image that wasn't there in the first place.

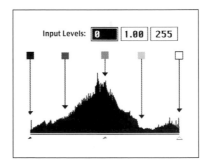

The positioning of the highlight and shadow droppers on a black and white photographic original.

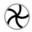

>Exposure

Most flatbed scanners can automatically detect the brightness range of an original, in much the same way that a light meter determines exposure in an SLR camera. Areas of light and dark are sensed during a preview scan, and a compromise setting is determined. This preview image also lets you make a visual assessment of the results. The auto setting will be fine for most normal situations, but not for print originals that display unusual characteristics, such as high key or low key images. Just as shooting black or white objects with a camera needs careful exposure adjustment, unusual prints require manual operation with dropper tools to measure the brightness range.

>The dropper tools

Most scanning software will allow you to use dropper tools to nominate the highlight and the shadow areas. This process ensures that images with an unusual brightness range are captured without distorting their special characteristics. Many scanner operators leave precise brightness adjustments for doing later on in Photoshop, where greater control can be exercised on the image.

>Understanding a histogram

The captured brightness range of an image can be viewed precisely in the form of a histogram. This useful graph shows the exact distribution of pixels of a certain brightness along the 0–255 scale. Histograms present complex information in an easy graphical form, so inexperienced users need not rely on visual judgment.

Input Levels: 0 1.00 255

Interpreting a histogram is the first step in understanding the captured brightness range in your images. Black is represented at far left and white at far right with intermediate values in between. The vertical lines describe the quantity of pixels across the 256-step range. RGB images have a separate histogram for each color channel, but a grayscale image has only one.

› Scanning a low-contrast image

Flat images consist of many grays and lack strong blacks or white. The histogram shape shows a peak towards the center with little or no distribution at each end of the scale.

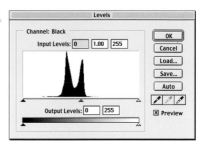

The histogram of the captured image, the two peaks represent the predominant two mid-tones.

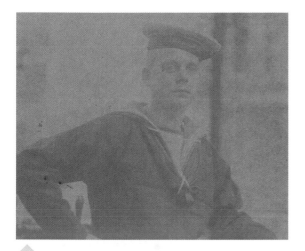

A faded photographic original, without highlight or shadow areas.

The shadow and highlight markers moved in between the two peaks.

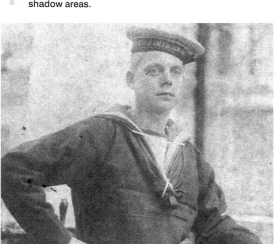

The resulting image after the histogram has been altered. Highlight and shadow areas have now been established.

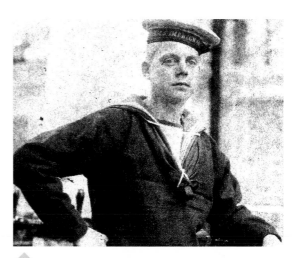

If excessive contrast is sought and the limited tonal range of an original is stretched out too far, posterisation occurs.

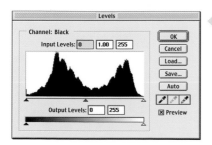

The final histogram showing the new distribution of tone.

The tonal range splits into distinct stacks. Future manipulation of this image may make the posterisation more evident.

> Scanning a high-contrast image

Contrasty images have black and white tones but few mid-grays. Excessive contrast is sometimes called posterization, where an image looks like it is created from a very limited palette of colors. The histogram shape for a contrasty image shows peaks at both ends of the scale, and troughs towards the center.

> Highlight and shadow clipping

Dropper tools can be difficult to use, especially if the preview image is small and of low quality. When used incorrectly to set highlight and shadow areas on an

image that actually has a much wider tonal range, the resulting histogram will show excessive values at both ends of the scale. As with photographic printing, good prints usually display minimum areas of pure white and pure black, together with a full range of grays in between. Used properly, the histogram can confirm your ability to capture correctly.

> Avoid at all costs

If your scanned image has gained contrast, it is far better to reset your tools and re-scan, as this will be quicker than trying to rescue lost detail later on.

The histogram for showing high distribution in the shadow and highlight areas, consistent with a high contrast photographic image.

The result of an incorrect use of the dropper tools, setting a much narrower brightness range than the original image.

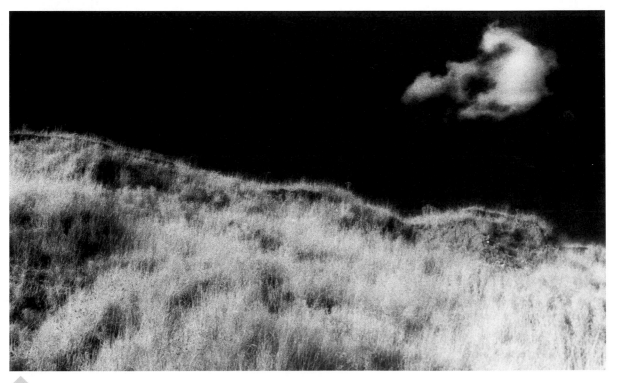

A high contrast infra-red image.

Chapter 6:
>>> Storage devices and file formats

>> STORAGE DEVICES

Digital images take up lots of data space on your computer's hard disk, and storage will eventually become a problem if you use the hard disk exclusively for this purpose.

As hard drives fill up, pressure on space can impair the performance of your computer so it's a good idea to leave as much free space as possible. Digital images are best stored on high-capacity removable media such as CD-R or Jaz and Zip disks.

Using removable media is the only practical way to transport image data when you need to use different computers at home and work. Many different manufacturers are involved in the design and production of external drives, and many standards and disk formats exist, most of which are incompatible with each other. You need to choose a drive and media combination that fulfils your own storage requirements, and can be read by all your likely destinations, such as workplace, client, or professional services. Consider reliable and rugged media with good archival prospects, such as CD-R discs.

External drives are connected to your computer by one of three common types of interface: parallel, SCSI, or USB. Each has a different kind of socket and allows variable speeds of data transfer to and from your hard drive. The parallel port is a printer interface with a slow data transfer speed. SCSI, short for small computer systems interface, is a faster connection and allows up to six separate devices such as a CD Writer, Zip Drive, and a film scanner to be connected to your computer in a chain. USB (Universal Serial Bus) is a recent introduction which permits very fast transfer rates, and allows up to 127 devices to be connected at any one time. All external drives are sold with an indication of their interface type,

for example a USB Zip drive or Yamaha CD Writer SCSI type II. If you have a plug that doesn't fit in your socket, there are many converters and adaptors available.

Much larger capacity external hard drives known as DVD-RAM drives are available too, and are best used for storing large volumes of valuable data.

DVD-RAM discs are relatively cheap and can store a massive 5GB of data, so they are useful for backing up. Backing up is the process of making extra copies of all your latest files onto an external storage medium, usually at the end of each day, by an application such as Retrospect. Loss of data can easily occur when your system crashes or discs become damaged, and many hours' work can be lost if your files have not been backed up.

> Formatting removable storage media

The Mac and PC operating systems need removable media to first be prepared for use, to enable successful reading and writing of data to take place. This preparation process is called formatting and in simple terms is the laying down of a system of concentric tracks on the disks where data will be stored. Mac-formatted disks have a different arrangement of tracks from PC-formatted disks, even though the media type, such as a 100MB Zip disk, may be identical.

Modern Mac computers can read from and write to PC-formatted disks, but PCs cannot read Mac-formatted disks of any variety. With other media such as Zip disks, the same applies: Macs can read PC Zips but PCs can't read Mac Zips. If you are likely to be swapping between the two, then only PC-formatted disks are practical.

With recordable CD-Rs, the process is similar but since common standards were established sensibly between manufacturers, the dual format ISO 9660 can work on both operating systems. If uncertain which you will use in the future, choose this as you cannot be disappointed later on. To complicate things further, disks can be reformatted

SCSI external hard drive.

An external disk drive such as a CD-R, CD-RW, or DVD.

(with the exception of CD-Rs), although success is by no means always guaranteed, and reformatting erases all existing data from the disk.

> Writing to CD-R

Aside from the option of choosing the most appropriate format for your disc, most CD-writing software, such as Adaptec Toast, allows you the option of writing to the CD-R disc in one single go, or to leave space to add more data later on. Single Session transfers the nominated data to the disc and, regardless of any spare space, closes the tracks to prevent any further writing. Multi-Session creates only enough tracks for the nominated data to be written and leaves any available space for future use. As each new session is added, some storage space is used in the process, and there will be a reduction in the overall capacity.

> CD-RW discs

A recent innovation is the re-writable CD-RW disk which can be erased and rewritten with new data when the old becomes unwanted. CD-RW discs are more expensive than CD-Rs, and you need a CD-RW writer to write to them.

>> SAVING IMAGE FILES

Image data can be saved in many different kinds of file types, known as formats. These different formats allow the user to package the data in specific ways to allow for future use in specialized applications, such as QuarkXPress.

Other file formats exist which are unique to one particular application such as the Photoshop file format (PSD).

Other file formats exist which allow image data to be compressed, i.e. reduced in size, enabling more efficient transport and storage. JPEG, TIFF, and GIF files can be used to reduce the data size of an image. The two types of compression used are Lossy and Lossless. The extreme compression of image files for serious work should never be considered, since irretrievable damage can occur. If emergency savings must be made in order to cram your large image file onto a Zip disk, for instance, then a TIFF with LZW (Lempel-Ziv-Welch) compression will be the most appropriate method to use.

When considering compressing a large image file, remember that the lossless TIFF saving routine is similar to rolling up a large printed poster and after unrolling, no permanent damage has occurred. The lossy JPEG, however, is like folding the poster into smaller squares and when it is unfolded, visible "crease" marks appear.

It is worth bearing in mind that most graphics, DTP, and web applications are only able to import or place certain file types, and a lot of wasted effort can be avoided if this is checked out first. Many applications do not have the ability to uncompress a JPEG image, or can import a TIFF file, but not a compressed TIFF. This minefield of compatibility can only be negotiated by checking compatibility with the programs you use most.

If you are only going to print your image files to a desktop inkjet from within Photoshop, using your own equipment and nobody else's, then you can save your files as Photoshop files and not worry about anything else.

> FILE FORMATS AND THEIR USES

Certain image file formats, like Photoshop EPS, are designed for specific use in DTP applications like QuarkXPress. Not all file formats, however, can be compressed or support multi-layered images when working in Photoshop.

> CompuServe GIF

Graphic Interchanged Format, or GIF, is capable of displaying 256 colors or less, and is used to save Indexed, or reduced color palette images for web use. Several variations of GIF exist, enabling transparent images, cut-outs, and even simple animation files to be produced for the Internet.

> TIFF

The Tagged Image Format File is a common file format for bitmapped images. A compressed version can be created too, using a process called LZW, without any evident loss of image quality. The saving from this lossless compression routine is about one third of the original file size. Mac and PC versions exist.

> PICT

Apple's own high quality compressed image file. Screen shots on the Mac are created in PICT format.

> EPS

Encapsulated Postscript image files are designed for use in page layout programs such as QuarkXPress. EPS files can contain a clipping path created in Photoshop, which is used to create irregular image shapes or cut-outs. Another variation of the EPS file is called a DCS (Desktop Color Separation) which was developed to allow an image to be split into color separations for future use in QuarkXPress.

> Photoshop

Photoshop's own format, known as PSD (Photoshop document), enables the user to save additional image information such as extra image layers. When working with layered images, all other file format options are usually dimmed or unavailable until the image has been flattened. Different versions of Photoshop have given rise to different versions of the Photoshop file, which are not backwards compatible.

> File extensions

These are the three letters appearing after your filename which denote the file format. The standard is to keep to three letters only. On a PC, file extensions are added automatically when you create any type of file, be it a word processed document or an image document. On a Mac, file extensions are not created for you unless you set up the preferences in each application.

> Swapping between platforms

File extensions are vital when you need to swap between computers with different systems. Many file formats such as .jpg, .psd, and .tif file formats can be read on both. Many applications will only recognize data that has been saved and named with the correct file extension.

> Native file formats

Some digital cameras save their images in unusual formats which cannot be read by Photoshop directly, so the image must first be opened and saved in a more acceptable format, such as TIFF or an appropriate plug-in, to convert within Photoshop.

> Photo CD

This was developed by Kodak, who decided not to license their smart compression technology to other software companies. Users cannot, therefore, save their own images in the unique Photo CD format. Picture CD is a recent development aimed at the amateur market.

File type	Data compression	DTP use	Internet use	Layers	Saved selections	Saved paths
Adobe Photoshop (.psd)	✗	✗	✗	✓	✓	✓
GIF (.gif)	✓	✗	✓	✗	✗	✗
JPEG (.jpg)	✓	✗	✓	✗	✗	✓
Photoshop EPS (.eps)	✗	✓	✗	✗	✗	✓
PICT (.pct)	✗	✗	✗	✗	✗	✓
PNG (.png)	✓	✗	✓	✗	✓	✓
TIFF (.tif)	✓	✓	✗	✗	✓	✓

>>DATA COMPRESSION

> Lossy compression

JPEG files allow image data to be compressed by assigning a compromise color value to a block of pixels, typically 9 x 9, rather than to each separate pixel. The extent of this process can be controlled but there is irretrievable deterioration in image quality, most noticeable in smooth gradient areas. The process is known as lossy, and close visual inspection will reveal damage. As images are opened and resaved, the damage will get worse.

> Lossless compression

TIFF files can be compressed using a different routine from JPEG, called LZW, which does not cause any perceptible damage to the image quality, but the savings are not so great. Lossless compression detects sequences or strings of similar colored pixels and reduces the need to have a separate instruction or code for each separate pixel. When saving TIFF files using the LZW compression routine, you have the option of nominating a PC or Mac byte order, with the PC option being most compatible with future use between the two platforms. GIF files are produced with lossless compression and, like TIFFs, no damage occurs when resaving.

The image has been saved as a TIFF file with LZW compression. No visible damage has occured. The file size is 1.7MB.

The image has been saved as a JPEG file on minimum quality 0, but with maximum compression. The file size is 52K.

An enlargement of the TIFF file.

An enlargement of the JPEG file to show the block damage created as a byproduct of the JPEG compression routine.

digital:photography:data compression

Chapter 7:
>>> Using Photoshop

>> THE PHOTOSHOP TOOLBOX

Photoshop was first developed at the Lucas Films studio to create special effects. Adobe bought the engine of the application and have since made it into the most versatile image editing application you can use.

This is the standard toolbox for Photoshop version 5.5. There is little difference between versions 5.0 and 5.5, but much between versions 4.0 and 5.0. There are 49 different editing devices in the toolbox, but only 20 are displayed at any one time. The remainder lie hidden in pop-up menus under those tool icons which display a small black triangle. Click and hold your mouse down over these icons to see the pop-up menu. Each tool can be pre-set with certain properties to suit the job in hand. Double-clicking on the tool will give you the tool's Options dialog box. The Options dialog is useful if you want to pre-set a characteristic before starting, to cut down working time. The pop-up menu, a small black triangle at the top right corner of the Options dialog box, gives you the chance to reset your tools back to default.

> THE SELECTION TOOLS

> Marquee tools

The Marquee tools are used to make freehand selection areas within your image or preset with a fixed size selection such as 100 x 300 pixels. Click-dragging the tool across the image creates an enclosed selection area. Selection outlines can also be filled and stroked with color to create simple graphic effects. Both the Marquee and the Elliptical Marquee can be used to create exact squares and circles by holding the shift key down before starting.

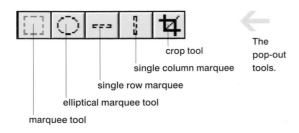

The pop-out tools.

crop tool
single column marquee
single row marquee
elliptical marquee tool
marquee tool

> Lasso tools

The Lasso tool enables you to make freeform selection shapes, using your mouse to draw like a pencil. The Polygonal Lasso is used to make straight selection outlines around geometric shapes, by clicking points on each corner of the shape in question. The last point must always meet up with the first, otherwise the tool will prove to be "sticky" and not easily deselected. The Magnetic Lasso tool is very useful if you are not used to drawing complex selection outlines around complicated shapes. Shape edges usually have a contrasting color value to that of the near background and the Magnetic Lasso senses the edge and drops anchor points along the route. You can alter the sensitivity of the tool by double-clicking it.

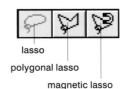

lasso
polygonal lasso
magnetic lasso

> Magic Wand

The Wand works like a magnet and creates selections based on pixel color. In practice it always picks up more than you really want it to, and is only entirely reliable when selecting solid color areas of an image. You can alter its "pulling power," or tolerance, by double-clicking the tool icon. Low values pick up only similar colors, high values pick up just about everything!

> Pen tool

Perhaps the hardest of all tools to learn, the Pen tool enables you to plot outlines in your image using anchor points and Bezier curves, a standard drawing system found in many graphics applications. Both curves and points can be adjusted to fit around complex shapes and are usually saved as paths. Paths are generally used to create cutouts, as they are much more precise than any of the previous selection processes and take up far less

The standard toolbox for Photoshop 5.5.

digital:photography:the photoshop toolbox

space if saved and stored as part of the image file. Clipping paths are created by designers to remove unwanted backgrounds around photographs, enabling page layouts to be produced with irregular-shaped images.

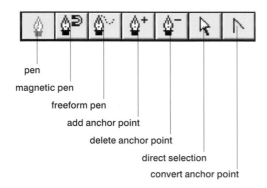

pen
magnetic pen
freeform pen
add anchor point
delete anchor point
direct selection
convert anchor point

> THE PAINTING TOOLS

All of the paint tools can be used with standard-shaped and -sized brushes from the Brushes palette. For more painterly effects, you can create custom brush shapes from any selection outline by clicking the pop-up menu on the Brushes palette and selecting Define Brush. Two additional brush sets are provided with Photoshop, but need to be loaded first from the same pop-up menu. They are found in the Goodies/Samples/Brushes folder. All of the painting tools are automatically loaded with the foreground color.

> Airbrush and Paintbrush

The easiest of the painting tools to use, the Airbrush creates a fine spray of color and is an effective tool for image retouching. If you hold your mouse button down and keep the tool in the same place, the colors spread out like a spraycan effect.

Similar to the Airbrush, the Paintbrush is useful for retouching down to single pixel units.

paintbrush
airbrush

> Rubber Stamp tool

This is the standard tool for cloning image areas in order to remove physical defects in your images. It gives you a quick and easy way to patch over visible marks, like spotting photographic prints. It is tricky to use at first because you need to watch two cursors simultaneously: the sample point and the painting point. However, despite the unfamilair technique needed to make it work properly, it is worth perservering with.

rubber stamp
pattern stamp

> History Brush

The History Brush is present in Photoshop versions 5.0 and later. Photoshop allows you to record the sequence of modifications you make when working on an image project. The History palette (present in Photoshop versions 5.0 and later) displays each separate command you have made, enabling you to undo your work in progress, up to the last 100 commands. Each command is called a state, which is in essence a separate version of your image. The History Brush works like an eraser, rubbing away an area of the current version to start again from a previous state which you can nominate.

> Art History Brush

Before the inclusion of this tool, it was difficult to make marks that resembled thickly loaded brushes dragging paint across a canvas, like the brush strokes created by Impressionist painters such as Claude Monet. The Art History Brush can produce a wet-on-wet look. It works by smudging your image into brush-like marks, which can be modified to create the effect you want.

history brush
art history brush

> Eraser

The Eraser works on single layered images by removing pixel areas, and replacing them with the current background color. In multi-layered images, it can cut through to reveal the underlying layer. It is also useful for montage work, allowing you to tidy up edges, after combining different images.

eraser
background eraser
magic eraser

> Pencil and Line tools

The Pencil tool is used to make adjustments to single pixels. The Line tool is useful for drawing simple graphic diagrams and can be set with pixel widths of 1–20. It can also be set to have arrow heads at either (or both) ends. Double-click on the tool to pre-set size and arrowheads. Holding down the Shift key when using this tool restricts it to creating only horizontal, vertical, and 45 degree straight lines.

pencil

line

> Edge modifying tools

These allow edges to be tidied up, particularly useful after cutting and pasting. The Blur tool softens edges down convincingly and the Sharpen tool sharpens them up but with random color artifacts as a by-product. The Smudge tool smears color into the direction of your dragging and can be used effectively to mimic hand-manipulated instant SX70 prints.

blur

sharpen

smudge

> Paint Bucket

The Bucket tool works in an identical way to the Magic Wand tool, but in addition drops the foreground color into the area defined by the tolerance value. As a creative painting tool, it is the equivalent of knocking a bottle of black ink over your work. It is best used for fast-filling large areas when making Quick Masks or Masks within channels.

> Gradient tool

This is not exactly a painting tool, but one which can be used to create graduated backgrounds, or fills from solid to transparent colors in many different shapes such as radial or angle gradient. Start and end colors can be chosen, together with precise control of the transition. Gradients are made by click-dragging the mouse. The greater the distance between start and finish points, which can also extend outside the image, the smoother the transition will be.

linear

radial

angle gradient

reflected gradient

diamond

> THE DARKROOM TOOLS

> The Dodge and Burn tools

The Dodge tool works in the same way as hovering a piece of card over a print in the darkroom to lighten an area of your image. The Burning tool does the opposite, and darkens down an image area. Both can be modified to adjust highlight, mid-tone, or shadow areas independently. They are only worth using on very small areas of an image, as they can create obvious circular effects if not used in a sensitive manner. They work with standard brush shapes and sizes.

> The Sponge tool

The Sponge tool has two options: Desaturate and Saturate. Desaturate is best used in RGB images to drain color away to grayscale without affecting underlying detail. Saturate gives you the option of increasing color saturation in a small area, but looks obvious if used to excess.

sponge

burn

dodge

> THE TEXT TOOLS

Text can be added to your image in two different ways. The Standard Type tool creates solid letter forms based on the current foreground color. The Type Mask tool creates empty text selection outlines, which can be filled with image pixels rather than flat color. There are vertical display options for both.

vertical type mask

vertical type

type mask

standard type

> THE NAVIGATION TOOLS

Hand tool

The Hand tool can be used to grip and move the image around, when it is enlarged and extending beyond the edge of the active window. Pressing on the space bar automatically selects this tool and then returns you to the last tool used when released.

Zoom tool

The Zoom tool is used to magnify parts of the image when working on fine detail. Holding the Option/Alt key down allows you to zoom out again.

> THE EYEDROPPER

The Eyedropper tool allows you to pick up a color from your image and load it as the foreground color. When retouching, it is best to use exisiting colors sampled from the image using the Eyedropper, otherwise your color nomination will be pure guesswork.

> THE COLOR SAMPLER

The Color Sampler is used to monitor color values during work in progress. By clicking the tool into shadow, highlight, or saturated areas, a mini densitometer is created to monitor change. Precise color values for each sample point are displayed in the Info palette.

color sampler

eyedropper

> Tool selection short-cuts

You can use the keyboard to make a short-cut switch to a different tool, by typing in the tool's short-cut letter. These are displayed in parentheses, such as (S) for the Rubber Stamp tool, when your mouse dwells under the tool in question in the toolbox.

> Context-sensitive menus

For very fast workers, context-sensitive menus offer the chance to keep working, without having to refer back to the toolbox, or to the drop-down menus. By clicking and holding down the Control key (Mac) or right mouse button (PC) a floating context menu appears over the image. This contains the most common changes you need, according to the tool you are working with. With the Rubber Stamp for example, you can scroll through different brush sizes without losing your place.

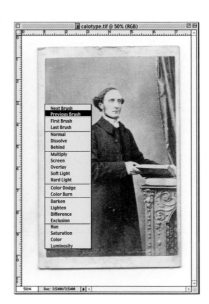

A context-sensitive menu.

> SELECTING COLOR

> Defining foreground and background colors

Painting, filling, and stroking all take place with the foreground color, while the patches created by cutting or erasing change to the background color. Both of these colors can be set in many ways, allowing you to pick the right color for the job.

> Using the Eyedropper tool

The Eyedropper tool can be placed over the image and clicked to sample a color value. This is a useful way to ensure an existing color from the image is used, rather than one plucked from the Color Picker dialog box. If you find the tool consistently produces the wrong color, you can set it to sample a larger area of 3 x 3 pixels. To change the background color using this tool, hold down the Option/Alt key when sampling.

> Using the Color Picker

Double-click either the foreground or background color box and watch the Color Picker dialog box appear. There are two areas: the Color Field, the larger square one, and the Color Slider, the narrower one. Click anywhere in the field to set the color, or scroll up and down the slider to change the hue. You can also set colors by typing numeric values into the text boxes. The small red warning triangle that sometimes appears, indicates that the chosen color, usually a very saturated one, will not print. You can also set the Picker to show only browser-safe colors, useful if you are working on images for Internet use.

> Custom color palettes

By pressing the Custom button in the Color Picker dialog box, you can load custom palettes, such as the Pantone scale. Useful for creating duotones, the Pantone scale is an internationally recognised color "recipe" book. Each color has a code number, enabling litho printers to mix it exactly, by weighing standard ink "ingredients." The coated and uncoated scales mimic the appearance of printed ink on glossy or matte paper stock. For fast scrolling through the Custom or standard Color Slider, hold the Move Cursor Up or Down key on your keyboard.

> Using the Swatches palette

The small Swatches palette can stay on the desktop as you work and allows you to work with a cut-down set of colors. Like an artist's palette, it is a one-stop shop, and clicking on a color square will instantly load your brush. The exact composition of the swatch can be changed, by adding and subtracting colors of your choice. You can even save custom swatch sets and bring them back again to use on later projects.

The standard default Color Picker with Photoshop.

An optional picker to use when preparing web graphics, showing the much reduced color palette.

The Pantone coated custom color palette.

The Photoshop Swatch palette.

digital:photography:the photoshop toolbox

>> UNDERSTANDING LAYERS

Think of an image file like an original negative, easily damaged when handled, usually irretrievably.

To avoid altering the characteristics of your original image file, Photoshop allows you to work in layers. Layers are a sequence of separate images which lie on top of each other, in much the same way as acetate animation cells do.

One of the most unsettling aspects of digital imaging is overworking an image and not knowing how to return to home base. Layers are one of many Photoshop functions that keep track of your work in progress. If you want to return to your original image, you can just delete the unwanted layers. New images remain as single-layered entities, named Background layer, in the Layers window. New layers are placed above this and blot out the underlying detail.

> Protecting your original image file

Adjustment Layers allow you to float an image adjustment, such as Levels, Curves, or Color Balance, over your Background layer. Adjustment layers do not contain any pixels, only settings, and can protect your original file from uncertain modifications. Unlike normal Levels and Curves, you can return and alter the settings by clicking on the circular Adjustment layer icon. You can also cut into Adjustment layers like a mask, allowing your adjustment to only partially affect the underlying image. An Adjustment layer only slightly increases the overall file size, and is much more efficient than working on a copy of your original.

Layers form in a vertical stack, like a pack of playing cards.

> Memory

As more layers are introduced, so the image file grows in size. With complex montages, using data from several different source files, the file size will keep rising. Each layer is, in effect, a separate image file and if you are working on a 24MB RGB file, which eventually becomes four layers, the size will grow to 100MB. For professional work, a large amount of RAM is therefore essential. It is good working practice to merge layers together once you gain confidence.

> File format

If you have more than one layer, you will only be able to save your image as a Photoshop format file, and the standard options such as JPEG, TIFF, and GIF will be ghosted out and unavailable. To package your image in any of these formats, you must flatten it first. Use Layers>Flatten Image to reduce it to one single layer, and then save as normal.

> Making montages

Montage is best done in layers. Each time you copy and paste from one image to another, a new layer is created automatically. Like a pack of playing cards, layers lie in a vertical stack, with the last one created lying uppermost. You can alter the stack sequence by dragging the layer icon and dropping it in its new position. You can lock layers together, too, like grouping separate elements in a graphics application, by clicking on the Link box.

> Layer opacity and Blending modes

By default layers are opaque and block out underlying detail. However, you can make a layer semi-transparent by using the Opacity Slider in the Layers palette. This is like printing from a sandwich of two negatives in an enlarger, and is a good way to blend image and texture together.

The Blending modes determine how the color of each layer reacts to the one underneath. There are many blending modes and they can create many unexpected effects.

> Swapping layers between different images

Layers are easily moved from one image to another by Layer>Duplicate Layer. It is even easier to use the Move tool, which allows you to drag and drop the layer icon into another image window. When you swap layers between images in different modes, such as taking a layer from an RGB image into a grayscale image, the layer takes on the color and resolution attributes of the destination file. This will convert your RGB layer to grayscale and may shrink or enlarge it if the spatial resolution is not the same.

Layers with transparent areas allow underlying layers to show through.

> The Layers Palette

1. The Blending modes menu. Click and hold to see the options.
2. Transparent area of layer.
3. Linked layer, groups layer with the active layer. Click to unlink.
4. Shows layer. Click to turn layer off.
5. Layer mask icon denotes active layer mask. Paintbrush icon denotes active layer image.
6. The layer image icon.
7. The layer opacity slider. Click and hold the triangle then move the slider.
8. Layer pop-out menu. Click to see the shortcut commands.
9. Adjustment layer. Double click to change the settings.
10. Layer effects icon. Double click to change the settings.
11. Text layer. Double click to re-edit the text.
12. Denotes active layer.
13. Layer mask icon.
14. Links image and mask together. Double click to unlink them.
15. The layer name. Double click to change name.
16. Makes new layer mask icon. Click to create a mask for the active layer.
17. Make new layer icon. Click to create a new layer.
18. Wastebasket icon. Click and drag layers into here to delete them.

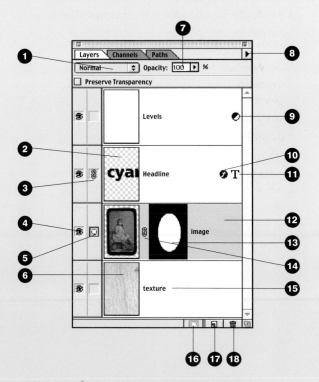

The structure of the Layers palette.

>>HISTORY PALETTE

For many years, it was only possible to undo a command immediately after the error was done.

The History palette, which was introduced in version 5 of Photoshop, gives you the option of reversing back, up to 100 commands ago, which is very useful if you are just starting to learn imaging techniques. Each command you make is recorded in the palette and given a short text description called a state. The History is not saved with your image file and is lost if you purge your clipboard.

> Setting up the History palette

Go to View>History and click on the History palette's pop-up menu, to reveal the History Options dialog. It is set to record only 20 commands by default, but you can increase this to 100, providing your computer has enough memory to cope.

> Using the History palette

History is helpful as the states give you a description of your last command. This is useful if you have pressed a key in error or made a mistake without knowing what it was! Look at the last History state and it will tell you what you've just done. As you work, new states are created from each command. To backtrack, just click on the state you want and the image reverts back. If you begin again from this point, all the states which come afterward are deleted.

> Making new documents

You can also make duplicate image documents. If you are not sure that a particular color or tone adjustment looks right, you can make it into a new document and finish up with different versions to choose from. From the History palette pop-up menu, choose New Document. This creates a new image in a new window, which you'll need to save with a different name from your original.

> The History palette

The sequence of recorded states, during work in progress.

1 History snapshot. Click to revert back to this point.

2 Denotes source state for History Brush or Art History Brush.

3 History palette pop-up menu. Click to reveal commands.

4 A named state which has recorded your command.

5 Current state.

6 Creates new document from most recent state or snapshot.

7 Creates new snapshot from current state.

8 Wastebasket. Click and drag states to icon to delete them.

> Snapshots

It's difficult to remember what your image looked like ten minutes ago when it was in a different state, so you can make a snapshot of its state to refer back to. From the pop-up menu, choose New Snapshot and give it a recognizable name. Snapshots become small thumbnail images in the History palette and if you click on them, they bring back the full version of the image for you to work on.

> Linear and non-linear history

You may decide not to use the extensive History options that Photoshop permits, but if you do explore these options, you need to be aware that your work, by default, is recorded in a linear sequence. When you backtrack to begin again from a previous state, all the states below this are deleted. If you want to keep absolutely everything and still refer back to these commands, you can select Allow Non-Linear History from the pop-up menu History Options.

> Purge

History states are kept in your computer's memory and will eventually fill it up, particularly if you set the History to go beyond 20. If you are working with high resolution images and using the History functions extensively, your computer will start to slow down, or refuse to carry out further commands as memory runs out. There's no need to quit the application and restart, however, as an Edit>Purge>All, will clear all History and Clipboard contents, and free up memory for the next command.

> ENLARGING AND REDUCING

As the pixel dimensions of a digital image are set when scanning or capture takes place, enlarging means adding new pixels to the mosaic. This process is called interpolation, or re-sampling, and makes the pixel grid area larger, but does so without creating any new detail. New pixels derive their color from adjacent (original) pixels and there are several different techniques for doing this. Bicubic is the best method where a new pixel is created by averaging the values of the surrounding pixels, but the nearest-neighbor method just duplicates adjacent pixels and produces jagged-edged results. The best method can be set as a default in Photoshop before you start work.

When re-sampling a whole image or transforming a smaller selection within an image, the resulting image will lose considerable sharpness because the number of invented pixels will exceed the original detected ones. There is no extra detail lurking in a pixel-based image and so it cannot be revealed like detail in an enlargement from photographic film. Avoid over-ambitious re-sampling, and if it is absolutely necessary, use an Unsharp Mask filter to regain some sharpness. Reducing means taking existing pixels away; going in this direction the process is less dangerous and will not cause a loss of sharpness.

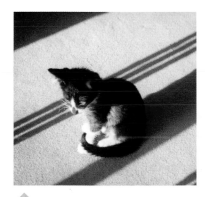

⬆ The starting point.

⬆ Resampled image using the bicubic method of interpolation.

⬆ Resampled image using the less effective nearest-neighbor method.

> Image size and canvas size

Two terms that are often confused with each other are image size and canvas size. In short, canvas size is always the same size as image size, unless you choose to increase it. Canvas size has nothing to do with increasing the printed size of an image, only creating additional space around it. With word-processed and DTP documents, page size is selected before starting a project. With digital images, the pixel dimensions of your image are the "page" size. There are two main reasons for wanting to adjust canvas size: to create extra space, such as an extra 2 inches of sky on the top edge, or to allow you to make basic page layouts and print more than one image per page on your desktop printer.

> Data size and canvas size

The new blank space created when the canvas is increased will be filled with the current background color or the transparent checkerboard pattern. Even though it appears blank, it is still created by a pixel grid making extra data. If the canvas size is doubled, the file size will double too.

> Printing with a white border

Most printer software can position the image exactly in the center of the print paper, regardless of the paper size or the image size. There is therefore no need to make large white borders within Photoshop as this would increase data size unnecessarily.

The canvas size dialog box for the image shows the current size above and the new canvas size below. The canvas has been increased by 2 cm in both dimensions.

The new canvas size is shown as a white border around the image; new canvas color is determined by the current background color, in this case white.

The width has been increased from 8.81cm to 27.81cm to make the extra space to create a montage.

The final result showing the new images and text in place.

>>CROPPING

To make the most efficient use of the computer's memory and storage resources, it is essential to reduce your image size to the minimum requirements of your output device.

Larger image files work the computer's CPU hard and take up memory resources, not to mention the final storage implication. Efficiency is the key, and an awareness of the minimum requirements of the output device will enable you to moderate resolution to the most appropriate value.

The binary code recipe to recreate the color value of a square pixel is identical, regardless of whether the pixel size is 1/300th of an inch or 1 inch square. Spatial resolution settings confirm the printed size of the square pixel blocks: either 72 blocks per inch or 300 blocks per inch.

Scan and save your image at your capture device's highest (and without interpolation) quality setting, and think of this as a film original. Save in an uncompressed file format such as TIFF and when printing or adjusting, work on a copy of this original file, leaving the "film original" untouched. Most inkjet printers produce their maximum print quality on 200 dpi image files. No additional print quality will be evident from a 300 dpi image printed on an inkjet printer.

Adjusting image shape is similar to cropping and composing using a baseboard easel in the darkroom. With a pixel mosaic, cropping off unwanted areas of the image will reduce the file size too, improving efficiency. The illustration of the tree started as a full frame 35mm scan, but was cropped down to remove sections off the top and left-hand edges. The Crop tool is dragged across the image, drawing a selection rectangle as it goes. Once drawn, you can adjust it using the corner and edge handles until you arrive at the right shape. Double-click within the area of the selection and watch your image become re-composed. If you find the selection edge automatically locks to the edge of your image, making minor crops impossible, zoom in to 200% and drag the edge handles into place.

The original image file for the tree was 12MB in size, which dropped to 8.7MB after cropping.

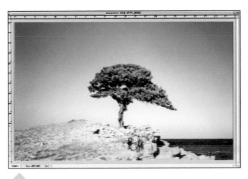

The image in its uncropped state.

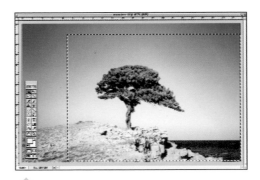

The Crop tool in action describing a smaller image shape.

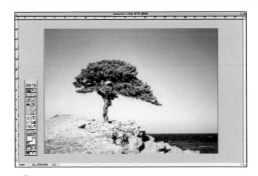

The final result, after the Crop has been applied.

>>SHARPENING YOUR IMAGES

Digital imaging applications like Photoshop have a built-in sharpening filter that can be applied to soft or unfocused images.

Sharpening, however, will never rescue badly blurred originals and has its limitations. It can tweak images to maximum sharpness, like a good enlarging lens can, and just like making the final focus check in the darkroom, it should be the very last stage before making a digital print. Many unrealistic projects end up badly over-sharpened, a process which is obvious and degrades the resulting print. Many digital cameras and scanners have the option to sharpen "on the fly" or at capture, and these should remain switched off or on lowest value.

Soft or unsharp images are characterized by fuzzy or low-contrast edges between shapes and their surroundings. Like high acutance developers for traditional film processing, which increase contrast at the edge of shapes, digital sharpening enhances the contrast of pixels at specified points in an image.

Despite the presence of four sharpening filters, only the Unsharp Mask filter allows you precise control of this delicate operation. The term Unsharp Mask is derived from a traditional film-masking technique and can be misleading as it increases the sharpness of an image, despite its name.

>USM Unsharp Masking

Three controls come with this filter: Amount determines the extent of the contrast increase, Radius sets the number of adjacent pixels that are taken into consideration when sharpening takes place, and Threshold decides which pixels are to be considered edge pixels. Different image types, such as flesh-colored portraits, require a different combination of these controls from, say, a product photograph, but experiment with these settings as a starting point: A:150, R:1, T:2.

The control panel for the Unsharp Mask filter in Photoshop. Three adjustments can be made with the Amount, Radius, and Threshold sliders. A preview of these effects is displayed in the small window. As the Radius values are increased, so visible artifacts appear in the images, such as color fringing and halo effects, together with a rise in contrast.

>Sharpening tips

False colors and strange shapes can appear after excessive sharpening, and these erroneous pixels are called artifacts. Any color, contrast, or other adjustment taking place after sharpening may make the artifacts more prominent, so only sharpen last of all, only if you need to, and just before sending to the printer.

>Mode change

After converting RGB to CMYK, any previous sharpening may become more visible, so avoid sharpening between mode changes. Sometimes changing to Lab mode and applying an Unsharp filter to the brightness channel can prevent color fringing occurring, because the colors lie unaffected in other channels.

>The blue channel

Often with scanned images or images from digital cameras, the blue channel will be noticeably noisier than red and green. Sharpening in red and green channels only, will prevent any magnification of the blue noise. Otherwise, apply a slight Gaussian Blur to the blue channel first, to smooth it before sharpening.

> The Unsharp Mask filter

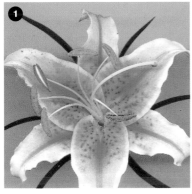
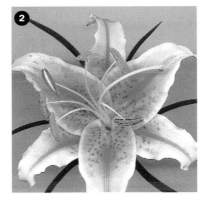

1 Unsharpened

2 A: 150, R: 0.5, T: 1

3 A: 150, R: 1.0, T: 1

4 A: 150, R: 1.5, T: 1

5 A: 150, R: 3.0, T: 1

6 A: 200, R: 5.0, T: 1

7 A: 200, R: 10, T: 1

8 A: 200, R: 20, T: 1

9 A: 400, R: 20, T: 1

The above examples show varying adjustments using the USM filter. Which setting has achieved the best result?

digital:photography:sharpening your images

> **Sharpening in Lab Mode**

⬆ An unsharpened RGB image.

⬆ A close-up of the clock face before sharpening in RGB mode.

⬆ A close-up of the color edged artifacts after sharpening in RGB mode.

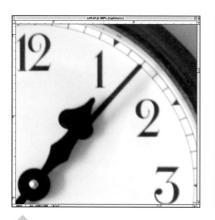

⬆ A close-up of the lightness channel image before sharpening.

⬆ A close-up after sharpening, note the absence of color fringing.

⬆ The final image after sharpening in Lab mode.

> **Sharpening in Lab mode**

An alternative way to avoid visible artifacts when sharpening is to change the image mode to Lab color. Lab mode images are constructed from two color channels and a lightness channel. Sharpening in the lightness channel only, where no color is present, avoids color artifacts appearing.

> **Photo CD**

Kodak deliberately prepare their Photo CD images unsharp, to allow greater compression rates.

Sharpening Photo CD images is therefore essential to achieve optimum results.

> **If in doubt**

Check with your professional services to see whether they would prefer to sharpen your images before print output, as they will know how to achieve maximum quality from their own professional systems.

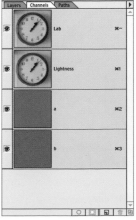

The Lab mode channel palette after the image has been converted from RGB into Lab mode. Note the absence of color in the Lightness channel.

>>SPOTTING AND BASIC RETOUCHING

Dust, hairs, and scratches still present a problem when scanning film originals and must be spotted out before any manipulation takes place.

Other image artifacts can be removed in the same way, and even red-eye can be corrected. Digital retouching is less risky than spotting photographic prints or negatives, because there's always the opportunity to undo your mistakes.

>The Rubber Stamp tool

It is essential to master the use of this tool properly, because it enables you to make invisible repairs to your image quickly. It works by picking up a mosaic of pixels from one area of the image, then loads your brush to paint with these pixels in another area. Even if only a small area of appropriate detail exists, this can be "cloned" and used to patch over a problem. No painting or color mixing skills are needed, unlike traditional retouching, but the clear identification of the best sample area is the key to making convincing repairs. You can also use the Rubber Stamp tool to cover unwanted detail, such as overhead electric cables which may spoil a landscape image.

Get your image to fit the full size of your monitor and zoom in to at least 300%. Sweep across your image from left to right by pressing the space bar on your keyboard with your non-mouse hand. This brings up the Hand tool enabling you to move around the image without swapping tools. Select the Rubber Stamp tool but double-check the painting cursor preferences first, under File>Preferences. The best option is Brush Size, as you can preview the exact area you are working on. Go to the Brushes palette and choose a smallish brush, around 20 pixels in size.

>Sampling the right area

Select the Rubber Stamp tool and place it over a suitable image area to sample. Press the Option(Mac)/Alt(PC) key and click with your mouse to pick up a sample. Release, then move the Stamp tool to the damaged area and click

to unload the sample. Click-dragging will allow you to retouch with paintbrush-like strokes, with the sample point remaining a fixed distance from your brush. The hardest part of using this tool is watching the sample point (the cross) and the stamping point (the circle) at the same time, in case the sample point drifts into the wrong area by mistake. The first example on page 76 shows an incorrect sampling taken from the blue sky (the cross) to paint out the white scratches on a red road sign; the stamping point (the circle) is painting a blue line on the red sign. The second example shows the sample point (the cross) correctly positioned on the red sign, and the stamping point (the circle) painting a red line to spot out the white scratches on the road sign.

>Aligned or Non-Aligned Rubber Stamp

Double-click on the Rubber Stamp tool to see if it is set up properly. Aligned option means the sample point is kept at the same distance from the brush as you work, and is the best option to use as you can sample areas running parallel to the damage. Non-aligned means that the brush is loaded with the same original sample area after each stroke, and will create an obvious patch if used repeatedly.

>Keep sampling

An artist would never repeatedly dip his or her paintbrush into the same pot of color. If you use the same sample point, a flat and conspicuous patch of color will appear, making it obvious what you've done. Over large retouching areas, keep moving the sample point all the time, varying the color, tone, and texture to achieve a realistic effect.

>Adding texture

If you do end up with an obvious patch which looks too smooth from the effects of cloning, you can add texture to it by using the Noise Filter. Make a selection of the area and go to Filter>Noise>Add Noise. A granular texture is overlayed, which helps to hide the evidence.

Unretouched image, with a scratchy sign post to be retouched.

The correct set-up for the painting tools in Photoshop.

How to modify the size, shape, and hardness of the brush.

The incorrect sampling of the wrong color area.

The correct sample point position.

The effect of not moving the sample point, creating repeated patterns.

> Obvious patterns

When you keep the same sample point throughout a lengthy bout of Rubber Stamp retouching, you will see patterns starting to appear in your image. This occurs because you are sampling the same patch of image repeatedly and stamping it down at a fixed distance, much like the regularity of a herring-bone pattern.

> The Brush options

Double-click any brush shape to reveal its characteristics. You can resize, edit the elliptical shape, and soften or harden the brush edge. The spacing control allows you to turn a smooth continous brush stroke into a dotted segmented line. Any modifications you make will be loaded into the Brush palette when you're finished, and you can always return to the default set by clicking Reset Brushes from the pop-up menu.

> Soft or hard edges?

Soft edge brushes are easy for a novice to use at first, but their soft edges cause minute blurring and loss of sharpness in your image. With extensive retouching over larger areas, this can become visible. The default brush set has a row of 100% sharp brushes on the top row, above the 0% sharp ones on the bottom. Hard edge brushes are unforgiving, but will retain more of your original detail.

>>> Link

You can also remove spots and scratches using filters, look in Color Restoration, page 84.

>>CONTRAST CORRECTION

Contrast in a digital image can be manipulated after setting the highlight or shadow points, simulating a Zone System level of control.

After scanning prints or film or acquiring images from a digital camera, there are several short-cut approaches to adjusting the contrast of an image, but only two precision controls: Levels and Curves.

> The Brightness/Contrast Slider

This works by applying the same increment of adjustment to each and every pixel in the image. If a +30 brightness was applied to a grayscale, all the pixels on the 0–255 scale would jump up 30 places. In much the same way that a Grade 5 filter works on variable contrast photographic paper, it can cause holes in the highlights and spreading of the shadows. It should not be used for a serious adjustment for print outcome.

> Gamma

Gamma is the extent of contrast in the mid-tone gray areas of an image. In the Levels dialog box, the gray triangle represents the gamma position and is linked to the center Input Levels text box, set at 1.00 by default. In the Curves dialog box, the default gamma value is depicted by the straight line slope. To compensate for the closing up of the shadow and near-shadow areas during litho printing, the gamma value can be increased to 1.20.

> Auto Contrast

The Auto Contrast command, found in Image> Adjust>Auto Contrast, detects the lightest and darkest pixels in an image and sets them to white and black. It ignores the first 0.5% of white and black pixels, ensuring those values are excluded from the process. Auto Contrast is a quick-fix solution that may suit your needs, but as it works invisibly and without a dialog box, precise control is sacrificed.

> Auto Levels and Auto Curves

Both commands produce the same end result. Like the Auto Contrast, they detect the lightest and darkest pixels, setting them to black and white, but this time for each separate color channel. The result may cause less adverse color shifts than the Auto Contrast command, but they are still not as precise as making the adjustment manually.

A grayscale image which has had three different contrast adjustments.

1. No adjustment.
2. Using the brightness and contrast sliders.
3. Auto Contrast command.
4. Auto Levels command.

> Levels

Levels is easily the most user-friendly adjustment for photographers to use and is a good starting point before moving on to more complex techniques. To bring up the dialog box go to Image>Adjust>Levels. After highlight and shadow points have been set, the gamma slider can be moved left or right until the desired visual effect is achieved. Sliding left will increase contrast and sliding right will decrease it. Unlike photographic printing, mid-tones can be altered without affecting the highlights or shadows. The Auto Levels command sets the white and black points for you, but like auto exposure on an SLR camera, never quite fulfills your exact expectation.

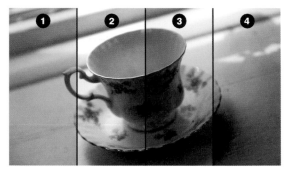

A color image which has had three different contrast adjustments.

1 No adjustment.

2 Using the brightness and contrast sliders.

3 Auto Contrast command.

4 Auto Levels command.

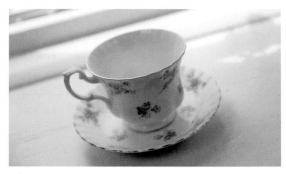

The finished version of the grayscale image which has had contrast adjusted manually using Levels.

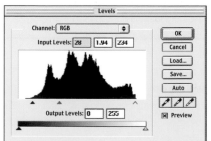
The finished version of the color image which has had contrast adjusted manually using Levels.

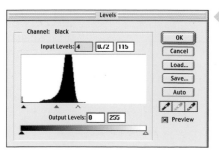
The Levels histogram for the above image.

The Levels histogram for the above image.

› Working with grayscale and color images

Grayscale images have a single channel: black. When adjusting the contrast of a color image, a composite of all separate color channels is loaded as default. You can edit this RGB/CMYK composite, or the separate color channels, using either Levels or Curves by selecting each channel from the drop-down menus.

› Curves

Adjusting image contrast using Curves can seem very complex at first with little visible guidance to aid you. Most new users just pull at the curve like an elastic band and end up canceling their efforts after going too far. Put simply, the straight line graph represents the 0–255 tonal scale with highlight at bottom left, shadow at top right, and mid-tone in the exact center. Like the Levels gamma slider, you control the contrast by pushing or pulling the center of the curve. Pushing upward decreases contrast and pulling downward increases contrast. If you have images which need only simple contrast adjustment, that's all you'll need to do.

Curves really come into their own when you want to adjust the contrast of a narrow tonal band, such as the near shadows or near highlights. Where Levels gives you three tonal areas to manipulate, Curves gives you up to 15. By moving outside the dialog box and into the image window, a dropper appears which allows you to sample the problem area. Do Option click, and that exact area is loaded as a point on the curve. This point can now be pushed or pulled, making the tone lighter or darker as desired. If the rest of the curve moves too, you can click extra points either side, preventing unwanted adjustments.

› Photo Parallel

Moving the gamma slider in the Levels dialog box is like using contrast filters in the darkroom for black and white printing, but without losing highlight and shadows.

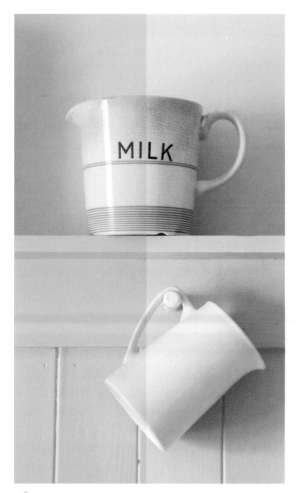

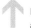 Before (left half) and after (right half) a Curves adjustment to correct contrast.

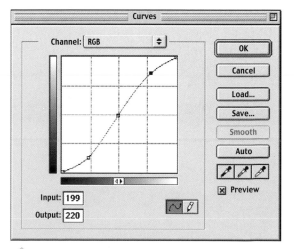

 The curve shape for the above image.

>>COLOR CORRECTION

For experienced darkroom users, digital color correction is reassuringly simple.

Like printing from color negatives, the purpose is to remove unwanted color casts that have occurred as a by-product of the location color temperature, film development, or scanning. Color removal is an exact science and if casts are not removed, they lie over the image like a colored varnish, lowering the saturation of other image colors. In the digital working environment you can make all the standard darkroom style corrections, plus more sophisticated ones, too.

> The desktop working area

You would never judge the color balance of a color photographic print which was displayed on a brightly patterned wall. Peripheral colors, particularly bright ones around the edge of a print, adversely influence your visual perception of color. When setting up your computer, avoid using bright and noisy desktop patterns on your monitor, as it will make the difficult task of detecting color imbalance that much harder. Before starting work, set a neutral mid-tone gray as the default desktop color.

Casts can be spotted more easily in the neutral gray (sky) areas of an image.

> Where to spot the color casts

The best place to spot color casts is in the neutral gray mid-tone areas of an image. Not the highlights, or any bright saturated color areas, only the mid-tones. Looking at the example of the field of yellow daffodils, the severe color casts are much more evident in the neutral gray sky area.

An example of a bright, badly colored pattern, making accurate color judgement impossible.

> Color variations

For inexperienced judges of color there is an extremely useful Variations dialog box in Photoshop under Image>Adjust>Variations. This presents a preview window with a color ring around it. In the center box is the image in its present state, which is surrounded by six color variations, plus a lighter and darker one, too. You can increase or decrease the increments of change, but it's much better to start midway between Fine and Coarse. Click on any variation that looks right, and watch it affect the center image. If you go too far, click on the "original" box in the top left, to take you back to the start. Like the Color Balance controls, working with Variations limits you

to editing the composite color channel only. If you want to edit the color of an individual color channel, then you need to use Levels or Curves.

> The color balance adjustment

Under Image>Adjust>Color Balance is a dialog box which gives you the standard color enlarger filter controls of Cyan, Magenta, and Yellow, against their opposite partners of Red, Green, and Blue, respectively. Offending casts are easily removed by sliding in the opposite direction to the cast, e.g. if an image is too magenta, slide toward green. Keep Preserve Luminosity checked, however, and this will retain the image's original tonal range.

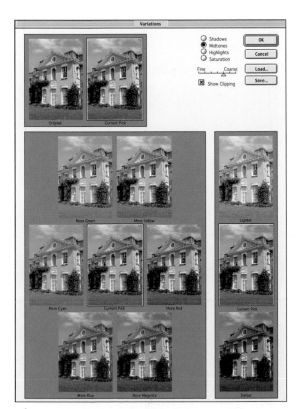

The Variations preview window in Photoshop enables simple color correction for inexperienced users.

The standard slider used to make basic color corrections.

> Using Curves

For complex color adjustments, where you may need to reduce one color without affecting the others, use the Curves controls. With Curves you can manipulate the color channels separately, increasing or decreasing the colors by pushing or pulling the curves respectively. This could be useful for opening up the detail in a heavily colored area, without affecting the rest of the image or modifying unsaturated colors. Only slight modifications are necessary; if you move the curve too far, the color becomes reversed, blue becoming yellow, for example.

Quick color correction

For a quick color correction, you can use the mid-tone dropper in the Levels dialog box. Open your image and bring up the Info palette on the desktop, by Window>Show Info. Then select the middle dropper tool from the Levels dialog box. Keep an eye on the Grayscale value (K) in your Info palette, and move your dropper outside the dialog box and into the image window. Move it over a neutral color area of the image, until the Info readout reaches 50, then click. Your image will now be fully corrected, regardless of the cast beforehand. Using the Info palette is a must, and takes the guesswork out of sampling colors that look like mid-tones.

Low saturated images

For color images that have low color saturation, a quick and simple method is to use the Hue/Saturation dialog box. Particularly useful after scanning color transparency material, the method can restore saturation lost in the process. Go to Image>Adjust>Hue/Saturation and make sure the Colorize box is unchecked. Work on the master channel and move the saturation slider until your color image regains its color.

Using the Selective Color dialog box

Individual colors can be enhanced using another method, the Selective Color dialog box, found in Image>Adjust> Selective Color. Here you can choose to modify a nominated color in the drop-down menu, by adding or subtracting cyan, magenta, or yellow. Once you have picked a color to adjust, cyan for example, all other image colors are left untouched. The example shows more cyan and magenta added to the cyan image colors, making the weak sky look more saturated.

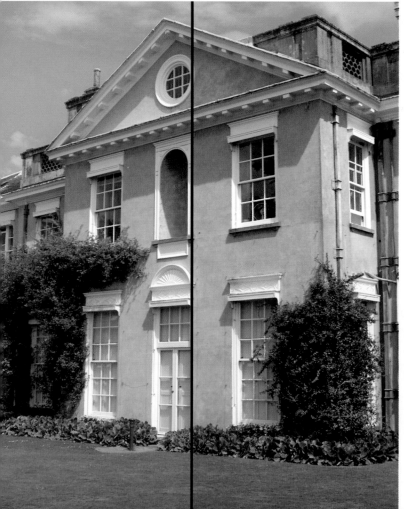

 Uncorrected (left half) against corrected (right half) color balance using the quick color method and the dropper tool in the Levels dialog box.

 The 50% readout for the quick color removal method.

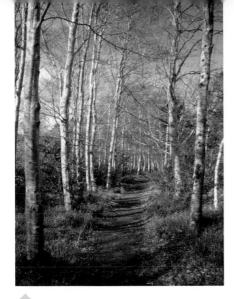

↑ The Hue/Saturation dialog box, showing the saturation slider at +25.

↑ Color image showing unsaturated color after scanning.

↑ The same image after the saturation has been increased in the Hue/Saturation dialog box.

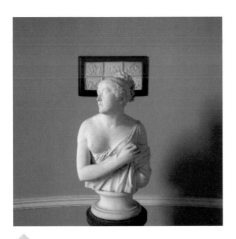

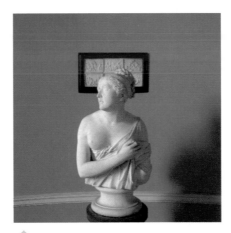

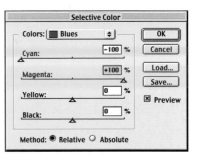

↑ The Selective Color dialog box showing blue changed by decreasing cyan and increasing magenta values.

↑ The starting point for a selective color change.

↑ The same image after it has been manipulated using the selective color command.

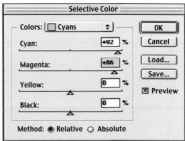

↑ The Selective Color dialog box showing cyan boosted by an increase in cyan and magenta values.

↑ An image showing a weak blue sky.

↑ The end result of increasing saturation, but only for the cyan in the image.

>>COLOR RESTORATION

Photographic images are prone to fading over time, especially color slides. Many early color-sensitive materials were unstable and have faded to a variety of colors.

Common problems are images that fade to a light cyan or light magenta, depending on the original film or paper stock used, together with the destructive effects of prolonged exposure to daylight. Remarkably, restoring the "original" color to these images is a relatively simple procedure.

> Scanning

Scan the originals without making any contrast adjustments in the scanner software, as the restoration of color is dependent on fine control of the highlight, mid-tone, and shadow points. You want to capture as much of the original detail as possible.

> Spotting and dust removal

Old slide film is prone to attracting dust particles, which do not brush off easily. Once the image is scanned, you are presented with the huge task of removing these marks with the Rubber Stamp tool. If there are too many to deal with, a simpler route is to filter them out with the Dust and Scratches Filter. This works by blending dark or light pixels (the scratches and dust specks) into the surrounding image area. The slight disadvantage to the process is an inevitable loss of image sharpness. Apply the filter lightly and with caution, keeping both Radius and Threshold values to a minimum. To try the filter go to Filter>Noise> Dust and Scratches. It's unlikely that your original is razor-sharp anyway, so the destructive effect of this filter may not make it visibly worse. If only minor damage is present, use the Rubber Stamp tool.

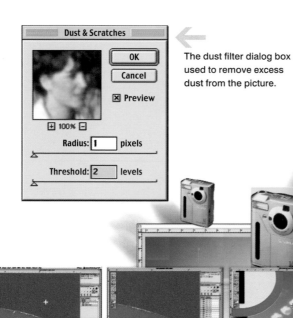

The dust filter dialog box used to remove excess dust from the picture.

> Analyzing Color

Once scanned and spotted, you can analyze the problems before you start. Go to your Levels dialog box and look at each separate color channel, to see the "missing" colors. Colors in photographic materials appear faded because they lose density in their mid-tone and shadow areas. In the Levels histogram, the black mountain-like shape will often peak and drop away before the shadow sector begins. Such a histogram shape shows, therefore, an absence of mid-tone or shadow pixels for that particular color channel.

> Restoring color

In the Levels dialog box, adjust the Red, Green, and Blue color channels separately by dragging the shadow slider to a new position at the foot of the histogram, shown as the red triangle in the illustrated examples. The color will change drastically as you alter each channel and will not look right until you have adjusted the final channel. Highlight points may need moving too, and can be slid along to the foot of the mountain, in the same way.

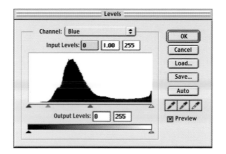

The blue channel.

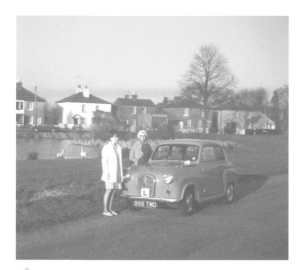

A 30-year-old color slide which has faded to cyan.

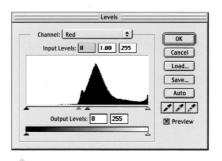

The red channel.

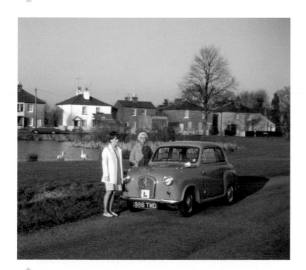

The image after color has been restored using Levels.

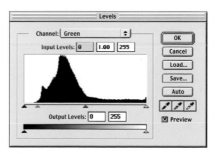

The green channel.

 A 25-year-old print which has faded to magenta.

 The image after color has been restored using Levels.

› Persistent color casts

You may discover persistent color casts still occuring after this adjustment, particularly in the highlight areas. You can remove these in the Color Balance dialog box, checking the Highlight button before you move the color sliders.

› Quick Fix

A faster method, which is worth trying if you have limited time, is to use the Auto Levels command at the very start, by Image>Adjust>Auto Levels. This works by setting the highlight and shadow point in each channel automatically, giving you an instant result, but without the precision of adjusting each channel separately. Small numbers of stray highlight and shadow pixels, creating a thin horizontal line along the bottom of the Levels graph, give false indicators to the auto adjustment and stop it working properly.

› Final adjustments

Some slight color enhancement may be needed as a final stage, perhaps to warm the image up. Color images that look blueish and cold are less pleasing than warmer versions. Adding yellow makes it warmer and is done by dragging the yellow slider in the Color Balance dialog box. If your image still looks a bit muddy, go to the composite RGB channel in the Levels dialog box and drag the gamma slider to the left. This will lift heavy mid-tones, making a brighter end result.

>> SELECTING BASICS

Selecting forms the basis of most Photoshop image manipulation.

Changes to an image, such as the careful adjustment of color and contrast, take place globally. For changes to smaller areas of an image, a selection first needs to be made. Like highlighting a word and changing its point size in a word-processing application, selecting in Photoshop creates a ring-fence around the desired area preventing manipulation spreading to parts of the image where the manipulation is not required.

Once an area has been selected, it is identified by a continuous moving dotted line, often referred to as the "marching ants." It is only the pixels inside this fence which are affected by the manipulation process.

Selecting can occur by three simple routes: through enclosing the area by tracing an outline, by painting a protective mask over areas you don't want to change, or by picking up areas of similarly colored pixels in a magnet-like fashion. Selections can be made in very precise ways and can be saved and stored as part of the image, which is very useful if you have spent a long time creating them. Many tools have been devised to enable you to make efficient selections in a variety of situations, but the hard part is knowing which technique to use in which situation. The following techniques are a good starting point.

> Tracing outlines

The Marquee tools are by far the easiest to use, making enclosed rectangular- and elliptical-shaped selections. Position the tool over the image and click, hold the mouse down, and drag to create the desired size and shape. If the Shift key is held down at the same time, only perfect squares and circles will be created. Not many elements in a photograph, however, exist with a perfect geometric shape and the Marquee tools have a limited use.

The Lasso tool, in contrast, enables the tracing of freehand selection shapes, albeit needing more skillful mouse control. Click, hold, and trace the outline with the mouse. The outline needs to be made into an enclosed shape for a selection to be possible, or it will make a "jump" between the first and last points created. Once you have finished tracing the outline, the marching ants appear, denoting a selected area.

You can modify an existing selection, cropping off mistakes or enclosing areas missed off first time. Hold the Shift key down and watch a "+" sign appear next to the tool, then simply make your adjustment. To subtract areas, hold down the Alt key and repeat as above. This works with all and any combination of the Marquee tools.

> Masking

In Quick Mask mode, Photoshop enables you to paint a virtual red mask over areas of the image you want to protect. For many print and reprographic professionals, this looks and feels very similar to painting with red photo-opaque or stripping red film during the platemaking process. When in Quick Mask mode, Photoshop creates a virtual mask using a 50% red default color. To apply a mask to an image, you can use a range of painting tools such as the Airbrush, Paintbrush, or Pencil, and the brush sizes are easily changed by a Window>Show Brushes command. Once you paint your protective mask, click back to Standard Edit mode and notice a marching ants selection appear. To add to or take away from your mask, click back to Quick Mask mode and use the painting tool as follows: increase the mask by using black as the foreground color, or cut holes through it using white as the foreground color. Toggle between the foreground and background colors by pressing X on your keyboard.

> The Magic Wand

The process of making selections by color is useful when an image is composed of strong blocks of similar colors. The Magic Wand tool works by picking up areas of similar color like a magnet picks up iron filings. By double-clicking on the tool, you can adjust its pulling power, or Tolerance, from 0–255. Lower values limit the tool to selecting very similar colors; higher values include more colors in the selection. By clicking on the image, a selection is quickly made. One problem with this tool is that it often picks up more than intended. A much better way of selecting by color is to use the Select>Color Range command.

> Color Range

The Color Range dialog box enables you to pick up existing areas of common colors such as reds, yellows, and greens. After nominating a color to select, in this case Red, you can preview the selection in the dialog box. After clicking OK, you return to the image with a marching ants selection. A more controlled way is to use the Sampled Color dropper tool, and pick a precise color from within your image window. A Fuzziness slider then allows you to expand or contract your selection, much like the Tolerance setting of the Magic Wand, with higher values adding more.

> Turning off selections

If Photoshop suddenly fails to respond to your commands, it is usually for one of two reasons: the Caps Lock on the keyboard has been pressed in error, or a selection area is still maintained somewhere in your image. To turn a selection off, go to Select>Deselect, or View>Hide Edges. A quicker way of doing this if you are using one of the Marquee tools, is to click anywhere outside the selection area; this automatically de-selects the previous selections.

> Softening the selection edge

Image adjustments within selection areas will look very obvious and hard-edged if their edges are not softened first. Feathering allows you to add a diffuse border of

 A filled selection without feathering.

 The same selection after feathering.

variable width to your selection, to create a more convincing blend with the rest of the image. This border is enlarged when you increase the Feather Radius value, found in Select>Feather. Selections are usually feathered after they have been made, otherwise the Marquee tools can be pre-set with a feather value. Another alternative is to use the Anti-Aliasing pre-set on the Lasso or Magic Wand tool. The effect of this is much less obvious, and it works by blending the selection edge pixels into the background, avoiding jagged staircase effects. Anti-Aliasing cannot be applied after a selection has been made.

> Inverting the selection

Sometimes it's easier to select the opposite part of an image that you want to change, because the color may be much easier to pick up, such as a white background around a fashion model. By doing a Select>Inverse command, you switch the selection to the previously unselected area.

>>> Saving selections

To find out how to save selections, go to Depth of Field on page 92.

>>> Running out of mouse mat

When tracing lengthy outlines with the Lasso tool, your mouse can accidently slip off the edge of your mouse mat, ruining all your hard work in the process. If you sense the edge of your mat is imminent, lift the mouse up, take it back to the center without releasing your finger from the button, and continue to work.

>>> Working tip

All tools can be pre-set to have special characteristics such as reduced opacity or feathered edges by double-clicking the tool icon in the toolbox. It is easy to forget you've modified a tool, unless you double-click it to check first. Click on the pop-up menu to Reset Tool to its default settings.

>>> Quick selection tip

You can select the contents of a layer by placing the cursor over the Layer icon in the Layers palette, pressing "Command (Mac) or Ctrl (PC)," and clicking at the same time. This is particularly useful if you are working with transparent layers.

>> BURNING-IN

The major difference between burning-in digitally and traditional printing is that in a pixel-based image, you won't encounter a very dense area, such as a white sky which is three stops over-exposed.

At their whitest, digital highlights will be point 255 on the scale, and can be easily lowered, or burned-in with the Brightness slider. Unlike their negative film counterparts, digital images will not take an excessive amount of time to burn-in. On the other hand, highlights in digital images do not contain lurking, invisible detail which can be coaxed out with extra exposure.

Avoid using Photoshop's Burning/Dodging tool as it only permits adjustments using the elliptical brush shapes in the Brushes palette. The problem is that you will end up with obvious circular patches in your image. A much better way to emulate photographic burning-in is to create a selection with the Lasso tool and use the Brightness slider to burn or dodge within.

> The Brightness/Contrast slider

Make a selection, go to Image>Adjust>Brightness>Contrast and use the Brightness slider to decrease (burn-in) or increase (dodge) the area in question.

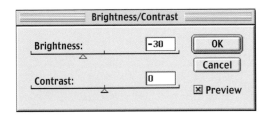

Treat this process like burning-in your print for an extra stop's exposure under the enlarger, and avoid drastic and sudden increments. Instead, make successively smaller selections, working toward the edge of your print and repeat the process two or three times, applying 30 units at a time. Too much too soon and it will look like you've left the enlarging lens open, making a blotchy image with no subtle gradation of tone.

Feather Radius Size

The extent of the feathered edge can be adjusted to lessen the visible effects of the brightness adjustment. The radius pixel values are in proportion to the pixel dimensions of your image, so a 150 pixel feather on a 640 x 480 pixel image will be enormous, but fairly small on

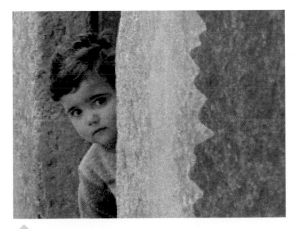

 The bad result of not feathering the selection.

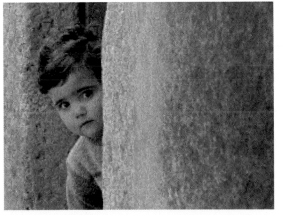

 A more convincing attempt using a feathered edge.

digital:photography:burning-in

a 3300 x 2200 pixel image. Too much feathering will let your burning adjustments bleed into nearby shapes, and too little will display a harsh edge. For high quality photographic images you need to adjust your feathered edge so the blending remains invisible after your adjustments. If you can see the edges, start again. As a starting point, set your radius to 150.

> Info palette

To keep a constant check on your burning-in and holding back adjustments, Photoshop has an Info palette which works by detecting the color or grayscale values lying underneath your dropper tool, giving you a running commentary. For grayscale images, it converts the 0–255 scale into 0–100%, where 0 is white and 100 is black (K). The value is displayed as K: 93%. When printing to an inkjet or dye sublimation printer, you will notice that these devices can't cope with the extremes as well as conventional photo paper can, so avoiding large patches of white and black is a must. Growing highlight and shadow areas can be detected precisely with the Info palette, which replaces arbitrary visual judgments with an exact read-out. Overcooking an image, by using a combination of different color and contrast adjustments,

can make adjacent pixels stand out from each other, giving your images a blocky pixelated appearance. Using only brightness adjustments will avoid this, and leave you with fine gradations and little or no jagged areas, providing your feathered edges are generous enough.

> Judging "exposure"

The key control is the Brightness slider, which emulates extra print exposure, and is the most effective way of adjusting the local "density" of a digital image. As each pixel has a fixed brightness value somewhere on a scale between 0 and 255, using the Brightness slider enables you to add exactly the same amount of change to each separate pixel. A minus 30 adjustment darkens the image by subtracting 30 values from each independent pixel and the value of this process is that its effects are global and fairly difficult to overcook.

> Quick Lasso selecting

A useful byproduct of feathering selections is that your original Lasso drawing can be very basic, as edges are smoothed out with the feathering.

> Transforming selections

If you want to retain the precise shape of your selection, but scale it down in size (which is useful if you are working around a complex shape), you can transform it by Select>Transform Selection. This lets you scale the selection area up or down, allowing you to burn-in smaller areas on your digital image; it is like moving your card mask closer or further away from the baseboard.

> Hide the marching ants

For a more intuitive approach to photo-printmaking, you can make the marching ants invisible while sliding the brightness up or down. View>Hide Edges turns them off and lets you compare the inside and outside of your selection side-by-side without the distracting dotted line. This is even better than photo-printing as you can see the density change happening before your very eyes, and contemplate the effect before committing yourself. The only problem with turning the selection edges off, is remembering to turn them back on again with View>Hide Edges, and deselecting before starting the next task.

The Info palette works like a mini-densitometer, detecting pixel brightness values within the image.

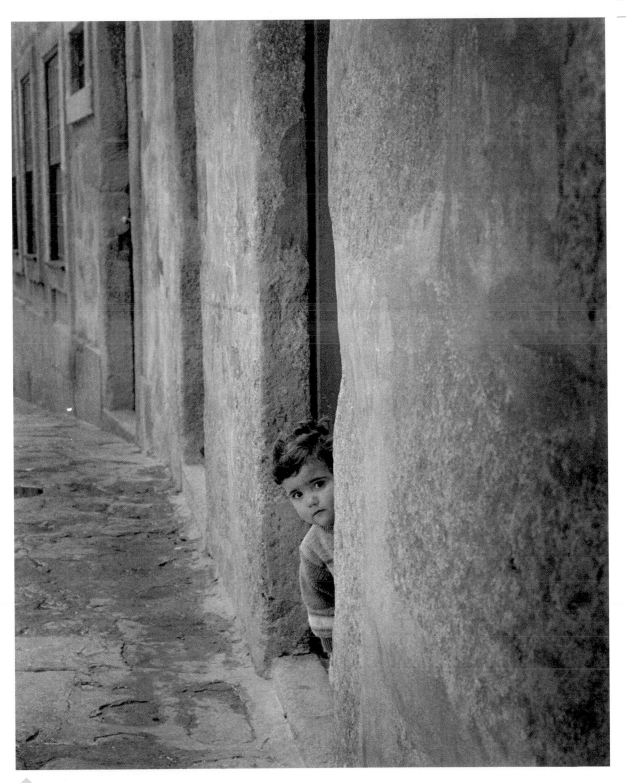

The end result with shaded areas like photo-printing.

>>DEPTH OF FIELD

Photographers have been able to control the depth of sharpness in their images by using different lens aperture values.

Depth of field, as it is known, is concerned with controlling image sharpness between fore, middle, and background picture planes. On camera lenses, smaller aperture settings such as f/22 permit maximum depth, while larger settings such as f/2.8 reduce this to a shallow space.

As a design device, using shallow depth of field to blur out the non-essential parts of your image forces the viewer to focus on the central subject of your image. Too much sharpness and depth, however, creates equal emphasis and can make your picture message unclear.

Often the background is the most important ingredient in making a good image, especially in sport or reportage.

Noisy, cluttered backgrounds with sharp edged shapes can be visually distracting. For photographers shooting fast-moving objects using telephoto lenses, it takes great skill to focus at speed and even greater courage to shoot at f/2.8, which gives little margin for error.

In Photoshop, you can assign a shallower depth of field to your previously over-detailed images, with a careful application of the Gaussian Blur filter. This is like re-shooting your picture with a larger aperture.

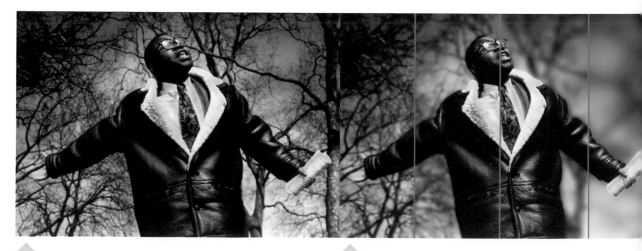

 A noisy tree background – the starting point.

 Different Gaussian blur values applied from left to right as follows; 5, 10, 20, and 40.

> De-focusing a noisy background

This image was shot mistakenly on f/16 and the trees are too prominent. To improve the image, it is essential to blur the whole background, but without any of the manipulation bleeding into the figure. Zoom in close to your image and view at 100% by View>Actual Pixels. Make a selection around the figure with the Magentic Lasso tool, pre-set with Anti-Aliasing turned on, and go as close to the shape's edge as you can. Once you have completed an enclosed selection around the figure, do a Select>Contract and enter a value of 3 pixels. This pulls the selection area inward, ensuring that no ragged edges affect the final blurring. Next, do a Select>Inverse and watch the selection. Now enclose the background. Feather your selection with a 2 pixel value, making the border between focused and blurred more believable. Finally go to Filter>Gaussian Blur and move the Radius value slider until the background is convincingly blurred out. To get a good idea of how this looks at the edge of your selection, move your cursor into the image window and click on a marching ant selection edge. This creates a close-up image of the edge in the Gaussian Blur preview window.

The dialog box for the final image.

The end result showing the trees blurred out.

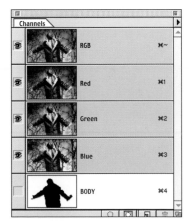

The saved selection from the project, as an alpha channel.

> Creating a realistic depth of field effect

This process uses selections in an identical way to burning-in but applies increasing Gaussian Blur filter values, in stages, to receding areas of the image. This way, you can mimic the way a camera lens creates an invisible "slice" or plane of sharpness, which gradually falls away, in both background and foreground directions. Before starting, make a simple sketch of the sharpness zones you want to create, like hill contours on a map. The example image needed the visually distracting figures,

behind the central figure, to be blurred, but in stages. The red outlines show a sketch of the planned sharpness zones that will be later selected for blurring. The central figure was selected first using the magnetic Lasso tool and the selection was saved by Select>Save Selection. The remaining zones were selected using a different method, in Quick Mask mode.

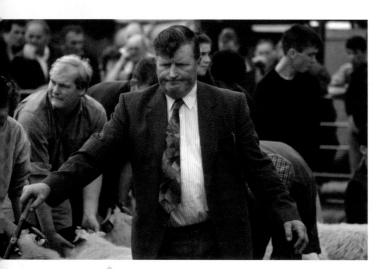

The starting point.

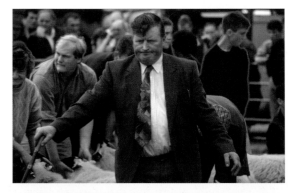

The different saved selection zones outlined. Different amounts of blur have been applied to these areas.

>Using Quick Mask mode

Bring the previously saved selection up by doing a Select>Load Selection. Now do Select>Inverse and then swap to Quick Mask mode. The red area denotes the protected parts of the image. Using the Airbrush loaded with Foreground Black, cover up the areas you want to exclude from this new selection. When you've finished, click out of Quick Mask mode and observe your selection outline. Save this and call it Zone 1. Repeat the process of loading the last selection, inversing it, and making a new mask until you have made enough to cover all the zones in your sketch.

To blur each zone, Select>Load Selection, slightly feather with 1 pixel radius, then apply a Gaussian Blur. In the illustrated example, ever-increasing Gaussian Blur values were applied to mimic the fall-off in focus to the following zones: foreground, 7 pixels; middle, 15 pixels; background, 25 pixels. To finish off, use the Blur tool to soften any zone edges which have not quite met up properly.

The red Quick Mask can be used to protect image areas in the selecting process.

The final image showing the effects of applying increasing blur to diminishing space.

> Saving selections

When you have made a complex and intricate selection
that would be time-consuming to repeat, you should save
it. The Select>Save Selection command allows you to give
your outline a name, and even nominate which image to
save it in. You can then call up the selection at a later stage
by the Select>Load Selection command. Selections are
stored in the Channels palette as alpha channels,
essentially like simple black and white stencils. They can
be edited too, using the painting tools loaded with black or
white. When saving, they will increase the file size
considerably and are not as efficient as saving paths
created by the Pen tool.

The images as they appear
in the Channels palette.

The saved selections as they appear as full-screen
alpha channels.

> Creating non-lens focus effects

Many darkroom wizards have been creating prints for years which have irregular areas of unsharpness, using secret gadgets and techniques. Usually, diffusing filters such as sheets of low-grade clear plastic, are hovered over the print during exposure. Results exhibit a seductive fall in and out of focus, which do not correspond to standard lens aperture effects. To mimic this effect, create a duplicate layer of your image by Layer>Duplicate Layer. Apply a weighty Gaussian Blur to this duplicate and then, using the Eraser tool, cut through the blurred layer, revealing the sharper original underneath. Pre-set the Eraser tool with the Airbrush option, and use a soft edged brush for smooth and subtle effect.

 An irregular sharpness laid down using duplicate layers and the Eraser tool.

> Creating 4 x 5-inch camera focus plane distortions

Using a 4 x 5-inch camera allows you to achieve precise control over object sharpness and shape, but also permits the creation of very seductive focus fall-off, and distortion through camera movements. The plane of sharpness can therefore be pinpointed to a very specific area, and a tiny one at that. In many recent commercial images, this technique has been used to great effect.

Mimicking the look of a 4 x 5-inch shot involves making a graduated selection, using the Gradient tool in Quick Mask mode. First, decide which plane your focus will lie in, before selecting Quick Mask mode. Use the Gradient tool and click-drag at a right angle to your plane. This creates a subtle graduated selection when you click back into Standard mode. Apply a slight Gaussian Blur filter to this area and then repeat the whole process, moving further out each time.

Finally, at the end of the object or the edge of the frame, apply a Motion Blur filter to mimic the distorting effects of the lens. In the illustrated example, a narrow band of sharpness was created to emphasize the textile design.

The red Quick Mask used to create the blurred effect.

The end result of blurring, to look like a 4 x 5 lens distortion.

digital:photography:depth of field

>> TONING A BLACK AND WHITE IMAGE

Color can easily be added to a grayscale original, through several different routes.

Historically, photographic print toning has centered around chemical toners such as sepia and selenium, which create a limited color range from browns to purple-reds, on black and white prints. With digital coloring, however, any tone or tint can be created and Photoshop gives you infinite control over the toning process. You can add color to the whole image, drop it into selection areas, or drop it into separate tonal sectors. Unlike the darkroom process, you can start off from a color original too, by Image>Adjust>Desaturate.

> Using the Color Balance control

This is like printing a black and white negative onto color paper, and using the enlarger's color filters to determine image color, but is much more sophisticated. The first step is to change the image mode from Grayscale to RGB to draw on the full palette of 16.7 million colors. Go to Image>Adjust>Color Balance and move the sliders until you achieve the desired effect. Keep to Midtones and check Preserve Luminosity for best results. Different colors can be added to highlights and shadows too, by checking their respective buttons and moving the sliders, making a more subtle mix. The example had yellow applied to the highlights, reds to the mid-tones, and blue to the shadows. You can even apply delicate colors to shadow areas separate from the mid-tones, but be wary of making the image too heavy.

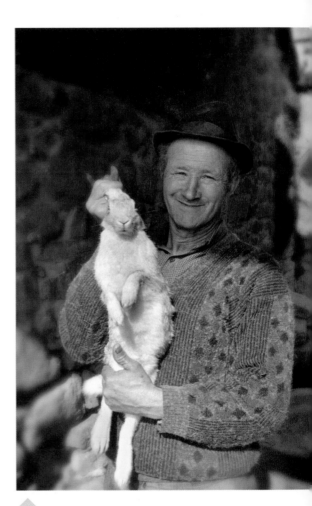

The image has been colorized using the Color Balance sliders, applying different colors in the shadow, mid-tone, and highlight areas.

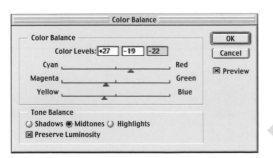

The dialog box for the image.

digital:photography:toning a black and white image

> Using Hue/Saturation

These controls give you the chance to tone with a similar range of colors, but also have additional control over the saturation or color intensity. Like split toning photographic prints, using Hue/Saturation can add delicate washes of color to your images. The Hue/Saturation dialog box is split into three sliders. The Hue scale is a linear representation of the color wheel, and sliding it along changes the color. Saturation dictates the color intensity, and lower values will look more realistic. Lightness is best altered in tiny increments or left alone altogether. Check the Colorize box first, and adjust the sliders until the desired effect is achieved.

The setting used to achieve the coloring effect.

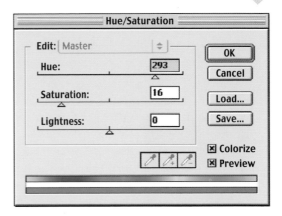

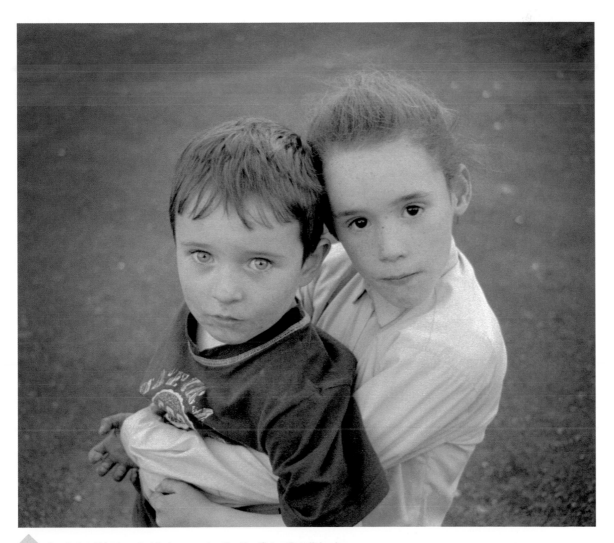

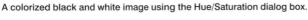
A colorized black and white image using the Hue/Saturation dialog box.

digital:photography:toning a black and white image

> Hand-coloring

Rather than applying color globally across the whole image, or in different tonal zones, you can "paint" a digital image like hand-coloring a print with brush and ink. Pick the Airbrush tool and double-click to bring up its options dialog box. Set the pressure to 50% and the blending mode to Color. Choose a feathered edge brush and load it

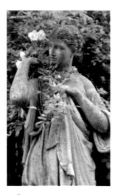

with a good color by double-clicking the Foreground color square. Now paint, and notice how the Color blending mode lets the underlying image detail show through, like ink does on a photographic print. For quick color changes, pick your colors from the Swatches palette. Clicking a small color square in the palette loads your brush. This example had a watercolor frame effect applied afterwards, from the Extensis PhotoFrame plug-in.

↑ A black and white image before hand-coloring.

↑ The final result of using the Airbrush to hand-color the image.

>>> Link

To look at how PhotoFrame works, see Using PhotoFrame on page 110.

> Draining color away

To drain color away, leaving a grayscale area in a color image, start with a color RGB, make a selection of the area you want to change, and go to Image>Adjust>Desaturate. This converts the selection into a grayscale and while the selection is still active, you can apply a Levels adjustment to regain contrast if it looks flat. For a more delicate effect, use the Sponge tool, found underneath the Dodge tool. Double-click to bring up the Sponge Tool options and select Desaturate. The tool works best with soft brush shapes and washes color away in strokes rather than selection areas. The example had a blue background before it was desaturated.

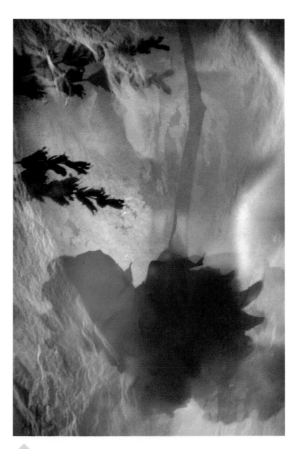

↑ This image has been partially desaturated using a selection.

>>DUOTONES

By far the most sophisticated way to tone a grayscale image is to use Duotone mode.

Duotones are traditionally used in the lithographic printing industry to reproduce high quality monochrome images, such as those found in art photography books. In order to mimic the look of an exhibition quality photographic print, which has been printed on a warm tone paper or with toners, additional litho inks are used. In basic lithographic reproduction, grayscale images are printed with standard black ink. Despite the 256 levels of gray present in the digital image file, the litho process reduces this down to about 50. The effects of this are commonly seen in newspapers and look very crude. Each additional ink color needs a separate printing plate, which adds to the overall cost. However, with each new color, a further 50 steps are added. For photographic images, warm brown and light tan inks are often used to mimic the look of a warm tone paper. For art photography books, part of their higher than average cost can be due to their tritone (three ink colors) or quadtone (four ink colors) printing and the complex film separations that need to be made.

Surprisingly, duotone (and tri and quad) mode digital images can be printed out by most desktop inkjet printers, so the process need not be restricted to litho output only. The most interesting aspect of coloring in this way is that you can work with a personal swatch of colors, dropping each one into specific tonal sectors.

> Making a duotone

Start with a grayscale image, then change the image mode. Choose Type>Duotone. In the duotone dialog box, black is set as the default first color and there will be a blank box next to Ink 2. Clicking this blank box reveals the Color Picker, where you can choose the second color. Pick a warm brown mid-tone color. Photoshop immediately updates your image window (behind the dialog box), to show you the effect. Next, click on the small curve graph next to the color square. Like the Curves controls, you can pull or push the straight line to darken or lighten the color.

> The Duotone Curve dialog box

If the concept of curves still eludes you, using the duotone curves will make things much clearer. As printing ink is usually expressed in percentage terms, the normal grayscale of 0–255 is converted to a 0–100% scale. The graph is divided into ten sectors, with each square representing a 10% step in tone. The line is a straight diagonal by default, meaning each original grayscale value is substituted with the same percentage of new color. You can manipulate the color by clicking anchor points on the curve and moving them. Pushing the curve into the pink zone of the illustration will darken the color, and pulling the curve into the white zone will lighten it. To make things even clearer, text boxes to the right correspond with your anchor points, giving a read-out of the new color value as you move the curve. If you want to leave the curve alone altogether, you can just type new values in the text box and watch the curve change shape.

Think of the percentage values as representing the tonal zones of an image, giving you enormous creative scope. If you want to stop the new color reaching the shadow areas, type 60 in the 100% box, watch the curve change shape and the color drop out. To allocate a lighter color to the mid-tones, type 10 in the 50% box.

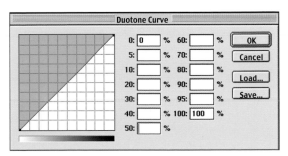

 The Duotone Curve dialog box.

> Making a blue duotone

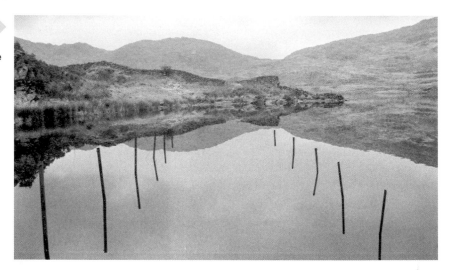

A grayscale landscape image before toning.

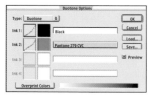

The two colors picked to create the final image.

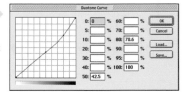

The curve for the distribution of black in the finished image.

The image after a blue duotone setting has been applied.

> Making a warm tritone

When you arrive at a combination and mix of colors that you like, you can save the setting as a Duotone settings file for use on future images. As with the hard-learned chemical toning techniques, you can preserve your findings and swap them with other users over the Internet.

A grayscale image before tritones are applied.

The same image after three colors are applied.

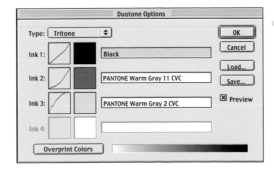

The dialog box and specific colors for the finshed image.

> The Duotone pre-sets

Photoshop comes with a set of ready-made duo, tri, and quadtone settings which can be loaded for use on your grayscale images.

Click on the Load button in the Duotones dialog box and pick up the files in the Adobe Photoshop/Goodies/Duotone Presets folder. There are some excellent examples that can be used to mimic warm, cold, or vintage photographic papers. The curve shapes in the ready-mades give you a good idea of how to control color distribution.

> Descending colors

You don't have to keep black as the darkest color. You can change it too, by double-clicking and picking another color, such as dark brown, for instance. You do need to build your colors in descending order, however, with the darkest color in the top box as Ink 1, and the lightest color in the bottom box.

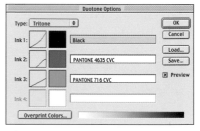

The dialog box and ink colors chosen.

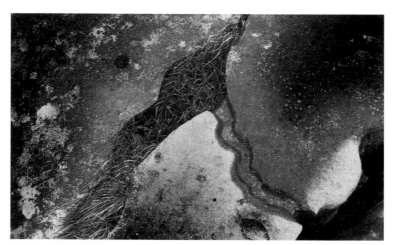

The grayscale starting point.

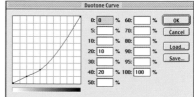

The mid-tone brown distribution.

The finished image after three warmer colors have been applied.

>>MAKING EDGES IN PHOTOSHOP

Creating stylish borders or edges for your images is achieved in the darkroom using a filed-out negative carrier.

For many photographers, such as Henri Cartier-Bresson, the trademark black line surrounding his images denoted that the print was made from the entire negative. In Photoshop, you can cheat a little and create customized edges in many different ways.

> Using selections

Just to complicate things a little, selection outlines can also become solid lines in any color you choose. To make a black border around your image, go to Select>All and notice the selection enclosing the whole image. Change the Foreground color to black, go to Edit>Stroke and make the width 5 pixels. Click OK and notice a black edge now appearing around your image. Unlike many drawing applications, Photoshop uses the term "stroke" instead of the more familiar "line."

> Using Blending Modes

A similar route can be taken after Select>All, by Select> Modify>Border. After setting the width, the selection area becomes an empty band, with a feathered inner edge. Do a Layer>New Layer and then Edit>Fill with 50% gray (or any color you want) and experiment with blending modes such as Difference. Click OK and notice that your border now blends into your original. You can also apply filter effects to your border selections, from the Filter menu.

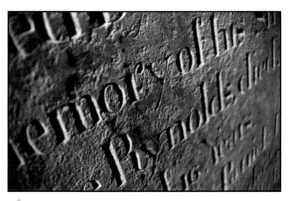

 An image after a simple stroked line has been applied.

 The same image with a blended edge using the Border command with a Difference Blend fill.

The Stroke dialog box used to create the effect.

The Border dialog box for the image.

The Layers palette showing the two layers in the image.

digital:photography:making edges in photoshop

> Colored borders

The previous techniques encroach into your image area. You can create borders outside the image, like mounting card, by increasing the canvas size. Under Image> Canvas Size, you can add extra width or height, and in different colors. New canvas space is automatically filled with the background color and by changing the background color between canvas size adjustments, you can create the illusion of layered mountboard surrounding your image. The example had the canvas size increased while white was the background color, then the color was changed to brown and the canvas increased again to give a different colored edge.

> Drop shadows

A drop shadow creates the illusion of your image hovering over a white background in a three-dimensional space. It needs two layers to work. First you need to make an extra layer by doing Layer>New>Layer. Double-click on the Background Layer icon and make it Layer 0, then drag this Layer 0 icon above the Layer 1 icon. This enables you to move the former background layer above the new layer, as normally the background layer can't be moved. Click on the Layer 1 icon and go to Image>Canvas Size and increase both dimensions by 1cm. Edit>Fill with white creates the white border. Click on the Layer 0 icon and go to Layer>Effects>Drop Shadow. In your image window, the effect will already have been drawn, but you can modify the shadow in the Effects dialog box. This process creates a special type of layer, called an Effects Layer, denoted by the small italic "f" symbol next to the Layer name. You can keep returning to the Effects dialog box and changing the effect by double-clicking this small icon.

>>> Link

Layer Effects are used to modify type, too. Go to the Adding Type section on page 135 to find out more.

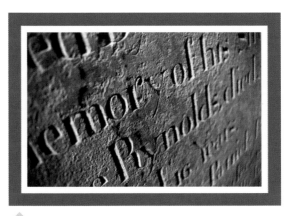

An image with two colored borders applied using the Canvas Size adjustment.

The same image with a drop shadow edge effect.

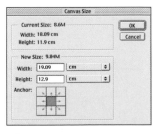

The dialog box to create the effect. Note the difference between Image Size and Canvas Size.

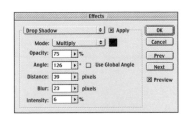

The settings in the Layer Effects dialog box to create the drop shadow.

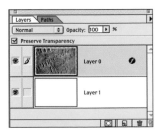

The Layers palette for the image. Note the "f" symbol, which describes the presence of an Effects Layer.

digital:photography:making edges in photoshop

>>SCANNING IN EDGES

Unusual frames and mounts can be scanned in as separate pieces of art work, and used to form outline shapes or frames for your digital images.

>Making a liquid emulsion edge

Photo-printing with liquid emulsion enables you to create scratchy image edges by applying the sensitizing solution onto your paper with a bristly brush. Convincing brush shapes can be defined in Photoshop, but it's much better to use the real thing. Drag a bristly brush loaded with black ink over an 8½ x 11-inch sheet of copy paper, in a shape that will become the final format for your image. There's no need to fill in the center, you can do this later on in Photoshop. Scan the sheet in as a bitmap image at 100% and at 600 dpi. Save and convert to grayscale, then RGB, and resample the image resolution back down to 300 dpi. Open your RGB photo image, and make the resolution 300 dpi and print size slightly larger than the black shape.

Next, click into your black image window and use the Paint Bucket and the Airbrush tools to fill in the empty center with black. Go to Select>Color Range and select Shadows and watch the black shape become an enclosed selection. Finally, Select>Similar, to ensure all peripheral black ink specks are rounded up and added to the selection. Click back into your photo image and do Select>All, then Edit>Copy. You now have a copy of your photo image on the clipboard. Click back into your black image and go to Edit>Paste Into. This drops your image into the selection area and masks off any pieces that lie outside the black shape. If the shapes don't quite overlap, Edit>Transform>Scale will enable you to stretch it to fit. You can re-compose too, by dragging the photo image with the Move tool. Any time you paste, or paste into an image, a new layer is created automatically.

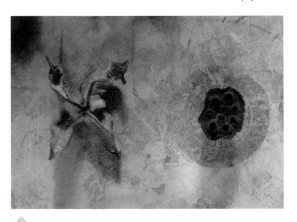

 The starting point for the emulsion effect project.

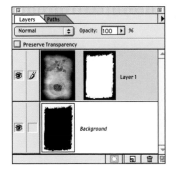

 The Layers palette for the project.

The brushy black ink shape, before scanning.

The image after scanning and filing, ready to select.

The end result of pasting "seeds" into the black shape.

> Scanning in a vintage mount

Excellent source material can be found in junk shops, for next to nothing. Pages from old family photographic albums may well have the kind of decorative finish needed to finish a recently restored image. Even if it is not exactly flat, scan using your flatbed scanner in RGB mode at 200 dpi. Use the Rubber Stamp tool to retouch any physical damage and remove anything you don't want, such as printed text. Make a selection of the print aperture, using the Magnetic Lasso tool or the Pen tool. Return to your image and do Select>All, Edit>Copy, click back to the mount image and Edit>Paste Into. Again use the Transform commands to scale up or down as required.

An image created by scanning in a decorative border from an old photo album.

> Peel-apart proofing or Polaroid film

Polaroid Type 55 is a very luxurious film, only available for medium- and large-format cameras, giving both an instant positive and negative, but is often only used for the random decorative edge it creates, when peeling the material apart. You could actually recreate the design of a generic Type 55 edge using Photoshop's brushes and drawing tools, but this would be a time-consuming task. It is best to scan a Type 55 print that you have previously made, and discard the central image. You can use the edge to frame any subsequent images, color or black and white, and in any format. Many photographers' image borders act like a signature, and the repeated use of the same modified negative carrier gives an identical edge effect to each print. With Photoshop, you can save your edge designs, duplicating the layer and saving it in a new document. From the Layers pop-up menu, select Duplicate Layer and save as a new document.

> Transforming tips

Remember, for excessive transformations, Photoshop will interpolate your image, so don't try and stretch it out too far if you want to retain maximum image quality. Try and have both scanned edge and image at the same resolution and print size, before you start assembling.

> Scaling without distortion

By holding down the Shift key when pulling a corner handle to transform an image, you can enlarge or reduce without distorting your image shape.

> Scaling from the image center

By holding both Option (Mac)/Alt (PC) and Shift keys down when using Transform>Scale, your image is scaled from the center outwards, which gives you a much clearer idea of the boundaries.

The final result, with edge and image combined.

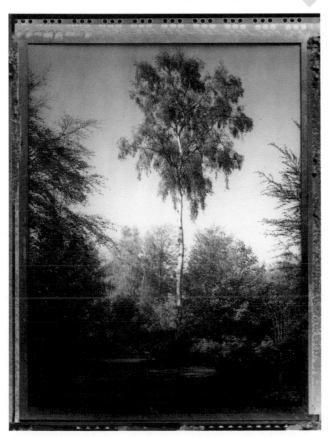

A toned black and white image and the starting point for the peel-apart project.

The assembled Type 55 edge ready to drop around the image.

>>USING EXTENSIS PHOTOFRAME

PhotoFrame is a Photoshop plug-in from Extensis, which comes with over 2000 different frames to use with your images.

If you don't have time to make your own special designs, then one from the PhotoFrame CD-ROM may do the job for you. The plug-in is excellent if you want to experiment with brushy manipulated print effects on your images.

>How to use PhotoFrame

After loading the software from the CD-ROM, PhotoFrame becomes a new drop-down menu option in Photoshop. After opening an image, go to Filter>Extensis> PhotoFrame and watch the large preview window appear. This gives you a large preview of all the effects you are building, with changes happening in real-time. Once you have chosen a frame, it becomes a new layer in Photoshop and can easily be removed at a later stage.

>Picking a frame

The frame files are best left on the CD-ROM, or they will drain storage resources if copied onto your hard drive. The frames are simple black shapes, which shrink to fit the size and resolution of your image when loaded. The thumbnail images can look fairly crude and unpromising in the preview window and it is not until they are loaded around your image that can you tell what the effect will be.

The Extensis PhotoFrame preview window in Photoshop.

This example has been produced with a watercolor frame, colored white, and blended using a Soft Light mode.

This image is surrounded with the same frames
(as below) but using different colors, blending modes,
and opacity values.

> Blending with your image

Like normal layers in Photoshop, the frames can be
merged with your image using blending modes such as
Overlay and Difference, together with an opacity slider.

Frame thickness, color, and sharpness can all be
adjusted until you arrive at an effect which complements
your image.

This example has been produced with a smudge frame,
again colored white but in normal blending mode,
cropping off the rectangular edge.

This example shows how several different frames can be
used all at once, each with different colors and blends.
Here, the frame colors have been sampled from the image.

digital:photography:using extensis photoframe

>>GRAIN AND TEXTURE

> Film grain

Fast speed black and white films give grainy photographic prints, and the effects are further magnified with push-processing. Grain is caused by the crystals of light-sensitive silver growing in size and becoming visible when enlarged in the print. For many years, film manufacturers have sought to minimize grain effects, but many photographers still produce grain-enhanced prints for creative effect.

> Photoshop grain

Although Photoshop has a Film Grain filter, it falls short of mimicking the real thing. The easiest way to create film-like grain is with the Add Noise filter. Start with an RGB or grayscale image and go to Filter>Noise>Add Noise, and experiment with the Amount slider. The higher the value, the grainier your image will become. The black and white example has a value of 130 applied. After applying the filter, you'll need to increase your contrast using the Levels sliders, to finish off the effect. With color images, keep the Monochrome option checked, or the noise will be created with undesirable high contrast RGB dots.

You can also use the Mezzotint filter found under Filter>Pixellate>Mezzotint. This gives you the option of producing different coarse and grainy effects. An image shot on very contrasty recording film, or a huge enlargement from a fast film, can look like a photo-etching and may be just the look you want.

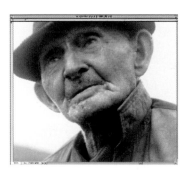

 A detail of a black and white image, before "grain" is applied.

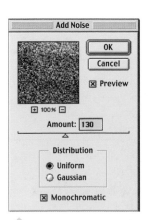

 The dialog box of the Add Noise filter used to create the effect.

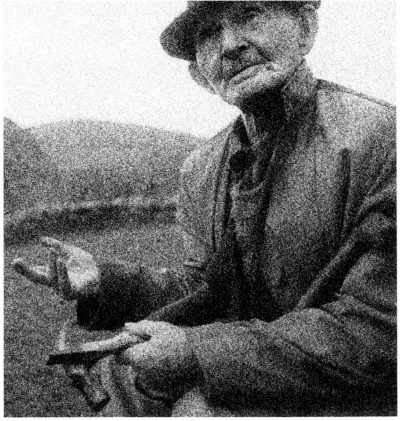

A full-size version of the grain-enhanced image.

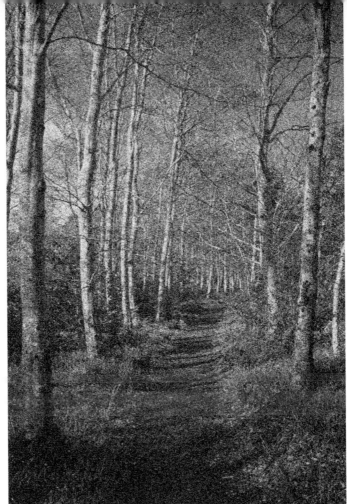

A detail of a color image before grain is applied.

The Mezzotint filter dialog box used to create the effect.

A full-size version of the grain-enhanced image.

A full-size image showing an alternative way to make a coarser grain with Mezzotint.

digital:photography:grain and texture

> Texture

The best way to create realistic paper texture effects is to scan in the real thing. Scanning a sheet of fibrous or irregular-shaped watercolor paper will give far more convincing results than any texture-generating filter ever will. Scan in your interesting source material as a grayscale and increase the contrast using your Levels sliders to show up the surface texture. Drag and drop the whole texture image over your photographic image using the Move tool. Notice there are now two layers. Click on the Texture layer and change its blending mode to Overlay, and watch the texture merge with the photograph. Finally decrease the Opacity slider, until it looks right. The example was created using an additional sheet of cream writing paper as a background.

Scanned paper textures, layered and blended to create the effect of vintage printing.

digital:photography:grain and texture

› Scratched and distressed

Scoring film or prints, and removing emulsion layers, is a cardinal sin for photographers as it offers no possibility of return. The distressed print look can be made easily in Photoshop, and without destroying your original material. Get a clear acetate sheet, large enough to fit your flatbed scanner. Score it with a sharp instrument, such as a scalpel or scissors, and scratch it with sandpaper. Dust it off and scan it in as a Bitmap or Lineart at 600 dpi. Convert it to a grayscale and increase the contrast so the scratches show up. Drop the resolution down to match the image you are going to distress. Finally, using the Move tool, drag and drop it into your source image window. Modify this scratchy layer using the Multiply blending mode, and watch it merge with your original image.

› Dragging Layer icons

Rather than copying and pasting, or dragging the whole content of an image window into another, you can mix images together by dragging the tiny Layer icon itself into the destination image window.

A sheet of scratched and sanded acetate after scanning and contrast enhancement.

 An image with the texture applied, cut, and arranged to fit the composition.

digital:photography:grain and texture

>>PHOTOGRAPHIC FILTERS

Color photographic filters work by preventing certain wavelengths of light from reaching the film.

Using deep color filters with black and white film, colors come out darker or lighter than we normally perceive. In a digital image, color values are easily modified and adjusted, just like using filters.

> Using the Channel Mixer

Photoshop gives you the opportunity to filter out color in each color channel, much in the same way as color filters work with black and white film. Like using a deep red 25a filter to make blue skies more dramatic, you can use the Channel Mixer to reproduce a similar effect from any RGB image. It's a bit like re-shooting all your color stock, but with deep color contrast enhancing filters. The Channel

Mixer gives you an easy route to creating very unusual color effects that mimic traditional film processes, and some that don't.

> Making a red 25a filter

Start with an RGB image which looks like it could be enhanced by the process, such as a landscape with a weak blue sky and white clouds. The hayfield image looked a bit dull, and would have looked much better if I'd shot it on black and white negative using a red 25a filter. To achieve this effect, go to Image>Adjust> Channel Mixer.

 A color image before a Channel Mixer settings is applied.

> ## The Channel Mixer dialog box

The sliders add or subtract color from each color channel. Remember with a deep red filter, reds come out white, greens come out much darker, and blues come out almost black. Click the Monochrome option and slide each color channel triangle to the following values: Red +200, Green 0, and Blue -100. You can add extra "exposure" to the image by moving the Constant slider: plus values make it brighter and minus values make it darker. Tweak the contrast using your curves.

> ## Using the Mixer to create other effects

As long as the new values of the source channels add up to 100, including minus values, your image will be adjusted without any loss of shadow and highlight detail.

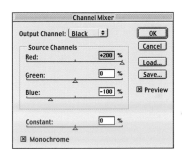

The settings used to achieve the effect.

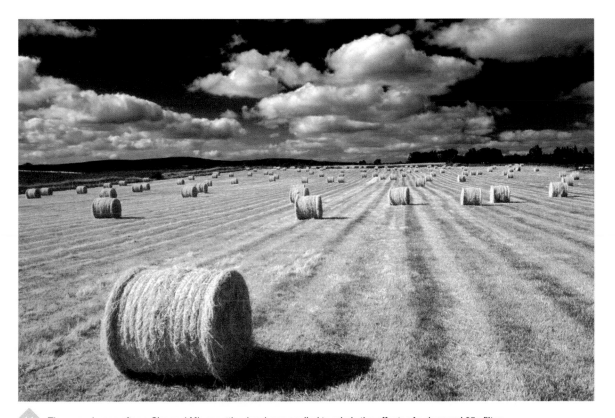

The same image after a Channel Mixer setting has been applied to mimic the effects of a deep red 25a filter.

>>COLOR INFRA-RED

Kodak Ektachrome Infra-Red transparency film has long been a favorite with photographers who experiment with different color effects.

It works by assigning false colors to the dye layers of the film, and is characterized by making green foliage turn magenta, and skin tones yellow. You can mimic the look of this film using the Channel Mixer.

> Saving your Channel Mixer filters

Once you've made the adjustments in each channel, you can save the recipes as unique Channel Mixer files. They become tiny data files, like duotone recipes, and will be about 5K in size. Much like a glass filter in your camera bag, they will be there to use at a later date. Store in a convenient directory and press "Load" in the Channel Mixer dialog box to apply them to your images. If you want to swap filters between a Mac and PC platform, make sure that the correct file extension .cha is applied after the filter name. The file only works within Photoshop, but many users distribute Channel Mixer filters over the Internet.

> How to make the effect

Open an RGB image that will benefit from the technique, such as a landscape with plenty of green foliage. The example of an ornamental garden looked rather mundane in its normal state. Go to Image>Adjust>Channel Mixer and adjust each Output Channel separately as follows:

>>>**Red Output Channel** Decrease the red source value to -100 and increase the green to +200.

>>>**Blue Output Channel** Decrease the blue source value to zero and increase the red to +100.

>>>**Green Output Channel** Decrease the green source value to zero and increase the blue to +100.

By now your image will have taken on the characteristic look of the manipulated example. The Channel Mixer settings below are only a guide; for different images you may want to modify other colors in the image, too.

>Using Adjustment layers in different modes

To make another variation on the image, go back to your starting point and make an Invert Adjustment layer, but use Hue blending mode instead of Normal. The green grass will now turn a lavender color.

The separate color channel recipes used in the Channel Mixer dialog box.

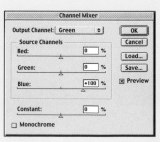

The starting point for the project.

The image after using the Channel Mixer to mimic the look of color infra-red transparency film.

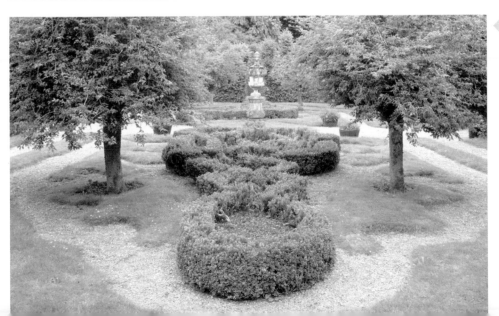

The image after an Invert Adjustment Layer is applied, to reverse the colors.

digital:photography:color infra-red

>>COLOR INVERSIONS

Fogging a print accidentally, and liking the result, is a formative experience for most photographers.

But, as you soon realize, making a second version of a happy accident is easier said than done. Solarization, an impossible mix of the positive and negative within a single image, is created in the developing stage, when sensitive material is exposed to light, creating a partial reversal of highlights and shadow areas. The resulting print can also display a curious fringing effect where highlight and shadow sit side by side. The precise control over where the reversal takes place and to what extent it occurs, is almost impossible to predict.

The starting point for the project – a flower scanned on a flatbed scanner.

> Sabattier effect

A major player in the Surrealist circle of artists and writers, Man Ray was a successful commercial fashion photographer, and the solarization technique first appeared in his work in the late 1920s. His prints were typified by a thick black outline surrounding his models, called a Mackie Line, which was a byproduct of the solarization process. These lines gave his work the unique appearance of a pencil drawing and photograph hybrid which was the perfect vehicle for the painter turned photographer.

> Making a solarized image

Start off with a grayscale image which has some sharp-edged shapes and a simple graphic composition. Keep your contrast to a minimum as any excessive highlights and shadows will cause printing to be problematic later

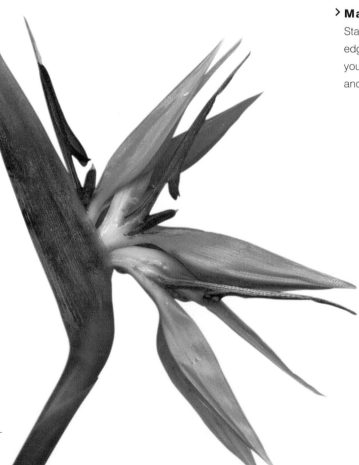

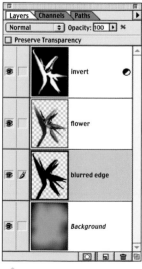

The Layers palette for the project.

on. The first step is to create an Invert Adjustment layer. This has the instant effect of floating a negative version of your image over the positive Background layer. It can also act as an opaque mask, or stencil, allowing you to cut through and reveal the layer underneath. As with any mask, you can make holes in it by using the Eraser tool to gently remove the layer bit by bit. The advantage of this digital technique is that you decide exactly where the solarization takes place, by erasing the Adjustment layer.

> Cutting through the Adjustment layer

Using the Eraser tool to rub through the Adjustment layer is a bit like having a paintbrush loaded with the reverse tone of everything it passes over, which is a disorienting experience at first. To confuse things further, the choice of foreground and background color makes a crucial difference. With white as the foreground color, your eraser will cut through your mask layer to reveal the positive layer underneath; but with black, the same tool will paradoxically repair the holes you've just created. Using a round brush with a soft edge, double-click the Eraser tool to amend the pressure setting if necessary.

Try working with low pressure values to start with, as this will give you the luxury of a couple of strokes of the tool to effect the result. Swap between white and black regularly to adapt your mask, as you'll inevitably remove too much to start with.

The most interesting parts of the image are the edges between highlight and shadow; a sharp edge is easier to reveal but softer boundaries need a bit of experimentation. To create a Mackie Line around your subject, stroke a selection outline with black and apply a light Gaussian Blur to give the look of a soft pencil line around the perimeter of your shape.

> Curves controls

Rather than using an Invert Adjustment layer, a more controlled approach is to make a Curves Adjustment layer instead. This allows the precise manipulation of your tonal range and can give a heavy or delicate solarized effect. The key to this process is to describe an irregular curve in a shape with the shadow value terminating on the same horizontal axis as the highlight. The steeper the shape, the higher the contrast.

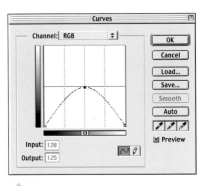

The unusual curve shape that can produce color reversals.

The finished sabattier effect picture after Invert Adjustment layer, showing the Mackie Lines around the edge.

digital:photography:color inversions

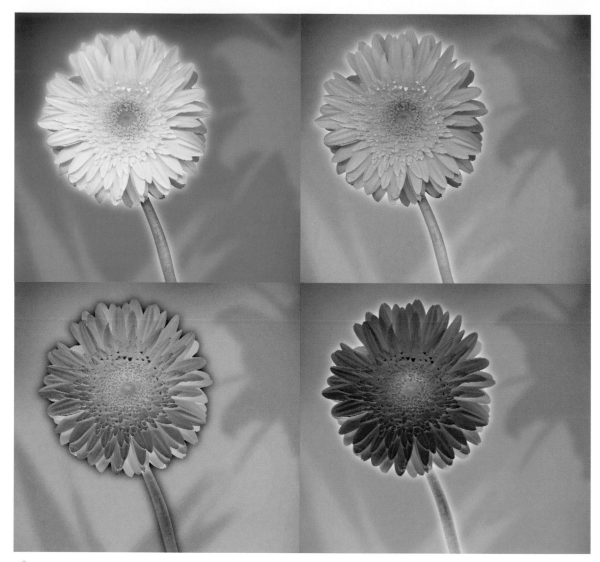

 Variations on the same image using Hue/Saturation adjustment layers and Invert Adjustment layers to reverse out the colors.

Color inversions

Color images can be manipulated with inversions, too. The best way to do this is to use the Invert Adjustment layer, which gives you opposite colors of the same tone and brightness, rather than the muddy tonal opposites available through Curves Adjustment layers. Although not strictly a solarization, it allows you to combine simple color opposites in one image. Remember that every layer that sits underneath the Adjustment layer will be inverted, so black becomes white, and blue becomes yellow. The four variations of the flower were made by keeping background, flower, and shadows as separate layers. After they were colored using Colorize in the Hue/Saturation dialog box, Invert Adjustment layers were applied to reverse out some of the colors. Sometimes, vivid color change gives you a totally unexpected result.

CMYK Preview

If you are preparing color images for lithographic output, you can still work in RGB mode, rather than CMYK, as long as you have CMYK Preview switched on. From the View>Preview>CMYK, your screen image will modify to show the likely litho printed result of your work. You can switch this off and on by pressing Command +Y on your keyboard. Vivid color adjustments will look less saturated when in this mode.

>>DIFFUSION

Diffusing an image in conventional photography is done by shooting a subject with a diffusion filter or a stocking over the lens.

In the darkroom, a similar effect can be achieved using a diffuser between lens and print. The diffusing fabric makes the image fuzzy and spreads image detail in all directions. The effect makes shapes bleed into each other with glowing edges, and is often used in advertising photography. You can reproduce the effect easily in Photoshop in a few simple steps. First, increase the canvas size to create a small white border around your image. Next, make a duplicate layer of your image by Layer>Duplicate layer. Apply a blur filter to this duplicate layer: go to Filter>Blur>Gaussian Blur and apply a 20 pixel radius blur. Click OK and return to your image. You'll notice that your uppermost layer has gone fuzzy; the next step is to blend this with the sharp layer underneath. From the Blending modes, choose Darken and watch the two layers blend to create the effect.

A close-up of the start.

The Gaussian Blur dialog box showing the amount used to create this effect.

A close-up of the effects of the blur before blending layers.

A close-up of the end result after the layers have been blended together, using Darken mode.

The Layers palette, showing the sequence and blend mode of the layers used.

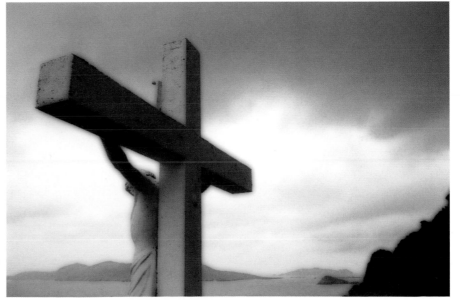

The end product, showing soft and diffused edges.

digital:photography:diffusion

>>LITH PRINTING

Photographic lith printing has grown in popularity over the last few years as many new paper products have entered the market.

A lith print is usually made by developing chlorobromide paper in high contrast lith developer. The characteristic of the print is a combination of low and high contrast, combined with an image color from light brown to orange, depending on the paper stock, developer, and exposure time.

Like many craft printing processes, lith printing can be unpredictable, expensive, and time-consuming. In Photoshop you can easily mimic the spread of shadows using your Curves controls, without anxiety.

> Making a lith print

More convenient than the conventional process, you can start from a color RGB image. Make your image a grayscale, then convert it into RGB and colorize using the Hue/Saturation command, making it a pinkish color. The next step is to reduce the contrast considerably, using the Contrast slider in Image>Adjust> Brightness/Contrast. Make it look very dull, dropping the value to -50, as this will represent the typical flat part of a lith print. Next make a Curves Adjustment layer and manipulate the curve to look like the example as follows. Peg the curve down in the the first quarter. Pegging prevents the whole curve moving when you start pushing or pulling it, and avoids things going completely out of control. Next, click on the mid-tone and push the point upward slightly. Finally, drag the shadow point along the baseline.

The infectious development in a conventional lith print occurs only in the shadow areas, so only move the black point of the curve within the illustrated portion to mimic the effect. All the unpredictable spread of shadow and high contrast can be controlled within this one tiny section, so only make delicate moves here. Moving along the baseline increases the infectious development of the shadows. If your curve does start to bend in places where you don't want it to, click a point down to stop it moving.

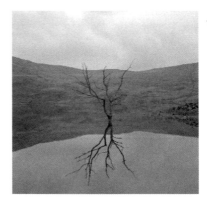

A dull underdeveloped image before enhancement.

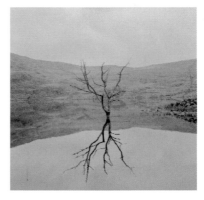

A lith-lookalike end result.

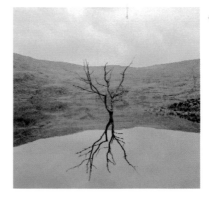

A variation which has been toned a different color.

Blending modes can further enhance the process, with Luminosity working best. Try Screen or Hard Light to bring some more saturated color back into play.

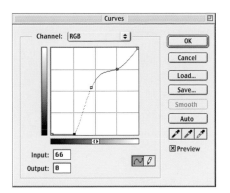

The starting point, this time from a color image.

The curve shape used to create this effect.

The red area denotes the point to manipulate to create this effect.

The image after contrast has been dropped using the Contrast slider.

The end result.

digital:photography:lith printing

>>CREATIVE FILTERS

Photoshop allows you to apply a wide variety of creative filters to your images, which work in much the same way as their screw-on counterparts.

One single filter rarely improves an uninteresting image, but with judicious application filters can be used to enhance your images.

Many filters create a strain on your computer's memory resources and can take time to work on the full image file, especially if you've got limited RAM or a small scratch disk. Keep the Preview option checked in the Filter dialog box, if it has one, and you will see the results more quickly. Another way to speed things up is to apply the filter first, in a smaller selection area. Many of the more sophisticated filters, such as the Lighting Effects filter, need a robust processor to work promptly, and machines with limited performance may slow down.

> Blending filters

Like layers, the effects of a filter can be blended using the standard Blending modes and the Opacity slider. You can control these options by selecting Filter>Fade Filter. The dialog gives you the familiar Opacity slider and mode menu options.

> Filter effects

The example shows six filters applied to different parts of the image. Starting at the top left and reading across is Distort>Glass filter, Distort>Shear. The middle row starts with Pixellate>Mosaic followed by Stylize>Wind. Finally the bottom row has Texture>Texturizer with canvas, followed by Texture>Craquelure.

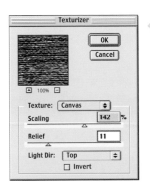

A standard filter dialog box.

A composite showing different filter effects.

The Fade dialog box that enables you to blend in your filters more convincingly.

A Motion Blur filter has been applied to the sky.

> Using filters for illustrations

Many creative filters can be used on images destined to play a supporting role in page layouts. In the above example, a Motion Blur was applied to a straight sky image to illustrate an invitation card for a photographic exhibition.

> Bitmap halftones

Bitmap halftones are not found in the filter menu, but they can make interesting changes to your image. You can make your image into a series of halftone dots, like the Pop-Art paintings of Roy Lichtenstein, then apply color afterwards. First you need to make your image into Bitmap mode, from RGB>Grayscale>Bitmap. You'll then be asked to specify a method of converting your continuous tone image into an only black or white bitmap. Pick Halftone Screen and from the Halftone Dialog box, pick the Round Shape. There are other shapes, too, with Diamond giving an interesting effect. Enter a low frequency such as 15, to give you a coarse dot size. The resulting image will look like a magnified section of a poor quality newspaper halftone. This pattern, incidentally, will cause a moiré interference with your monitor as you zoom in and out, which can be misleading, but the printed result will not show these patterns. If you are sending them to litho print, be sure to let your printer know what you want to achieve.

> Coloring the halftone

Changing the mode back to RGB allows you to add color, using either the painting tools or by using Edit>Fill on selection areas. Work in Multiply mode only to retain the underlying dot detail.

The end result of applying a bitmap halftone effect.

The dialog box that appears when you convert an image into bitmap.

The halftone design options presented after the previous dialog box.

> Saving the curve

If you want to repeat the effect on future images, you can save the curve by pressing the Save button in the Curves dialog box. After giving it a name, make a new folder within Photoshop to retrieve it from at a later date. In the Curves dialog box, press Load to bring it back.

digital:photography:creative filters

Chapter 8:
>>> Photoshop montage

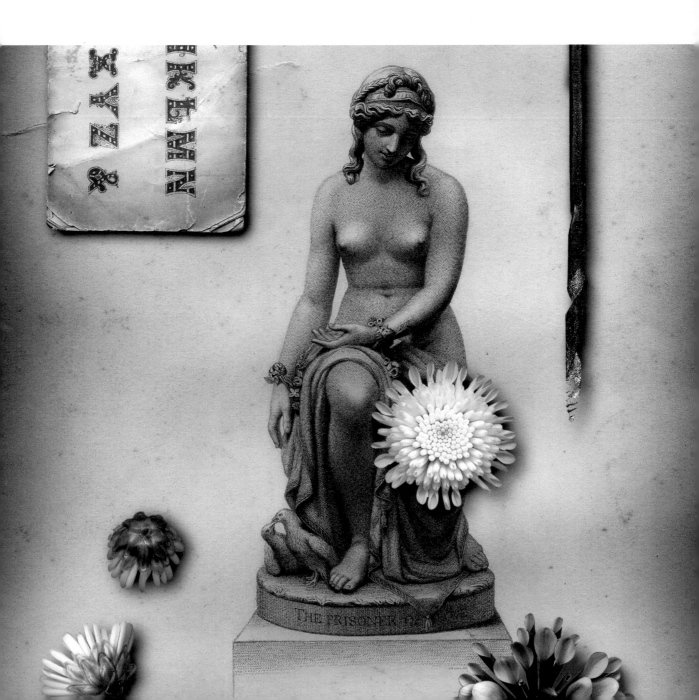

>>PHOTOSHOP MONTAGE

Montage is the combining of images together in a new design.

Traditionally, photomontage was a tricky process, using scalpel, glue, and a copy-camera to re-photograph the resulting collage. With the invention of halftoning, enabling photographic images to be reproduced by printing press, many political and propaganda statements were photomontage. Scaling the source material to the right size beforehand was a must, and the whole process took many hours to complete. Using Photoshop, you can make highly complex montage by merging and blending images together, and adding text, too.

> Cutting and moving

Precise cutting out is the key to making separate images fit together. You can do this by selecting the unwanted colors, using the Color Range command, then doing an Edit>Cut to remove them. Otherwise, you can make an enclosed selection, then Edit>Copy it to the clipboard. Open a new image and you can Edit>Paste the clipboard's content into your image. Use feathered selections if you want to merge the edges of your shapes and prevent the process from looking too obvious.

> BLENDING MODES

For this illustration, a sheet of Indian handmade paper, with an interesting texture, was scanned, then cut out with the Pen tool and given a drop shadow. The flower image had a decorative edge applied to it using Extensis PhotoFrame. This was then cut away from its background by selecting the white space, using the Color Range command, then Edit>Cut. Cutting away the spare white space creates transparency, and is denoted by the checkerboard pattern. Now Edit>Copy the flower, and click into the paper image. Do an Edit>Paste and watch the flower appear in the image.

Without blending, the flower layer sits uncomfortably over the paper texture. You can create a very different effect by changing the blending mode of the flower layer. In the following examples four different blends were applied: Normal, Multiply, Difference, and Luminosity.

↑ The starting point for a simple montage, a sheet of handmade paper.

↑ The image to go on top of the paper.

↑ The two images combined, using Normal blending mode.

↑ The image using Difference blend.

↑ The image using Luminosity blend.

↑ The image using Multiply blend.

digital:photography:photoshop montage

An image showing assembled materials from many different sources. (Image by Luzette Donohue)

> CHERUB

In this example, Luzette Donohue has created a montage by combining scanned images with film strips, textured papers, and xeroxes. Using different blending modes for each layer, and varying the opacity of the layers, she adjusted the dominance of each separate picture element. Remember, you have to click on the layer first, before defining its blending and opacity characteristics.

In the second example, Luzette has created a more complex image, using unusual source material such as leaves, line illustrations from a reference book, a vintage photograph, and some paper textures. New text was overlaid and blended in. The combination of blending modes is further increased if layer colors are inverted. With such a big task, involving radical color changes, it is important to work in CMYK Preview mode. Many bright color effects, when working in RGB mode, simply won't translate to inkjet or litho output, and it is much better to keep a check on this as you are working.

> Gamut Warning

Go to View>Gamut Warning to see which color areas will prove to be a problem when printing. Photoshop's default Gamut Warning color is gray, which immediately tags the problem colors.

> COMPOSITE IMAGES

You can create a montage from many different images, with each one retaining its own space in a grid. Making higher resolution images from many low resolution images is a good way around the limitations of a basic digital camera. Paul Tucker created this image by shooting small model cars with a Sony Mavica digital camera. The camera allows very close focusing and uses a standard 3.5 inch floppy disk to store the image files. It produces very small 640 x 480 pixel images, which Paul used as smaller building blocks in a larger image. Eight source images were taken, then assembled in a new 300 dpi image file, with each car as a separate layer. The colors were then intensified using the Hue/Saturation adjustment.

A more complex image using layer blending modes to create interesting color effects. (Image by Luzette Donohue)

> SEAMLESS MONTAGE

For the button images, Paul scanned original 6 x 7-inch transparencies, and doubled the vertical canvas size. The image was then copied and pasted into the empty space, and flipped horizontally through 180 degrees, to look like a mirror image. Using the Eraser and Rubber Stamp tools, Paul then modified the buttons and shadows, until the seams and overlaps disappeared. Using the Gaussian Blur filter, focus and depth of field effects were added to make the blending even more convincing.

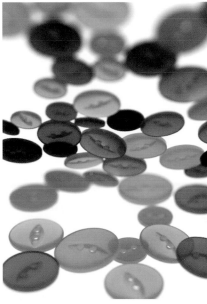

A seamless montage made by copying and pasting the same image. (Image by Paul Tucker)

The same process, this time using the Rubber Stamp tool to blend the two together. (Image by Paul Tucker)

A composite image created using small images shot on a digital camera, then assembled in a grid. (Image by Paul Tucker)

>>STILL-LIFE MONTAGE

The flatbed scanner is an excellent capture device for creating still-life images.

Amazingly, it can capture a single facet of a 3D object, with up to an inch of sharp focus too. All photographic images are created from a single fixed viewpoint, and the best still-life photographs are attempts to record the very essence of the objects. Think of your flatbed scanner like a fixed copy camera, and assemble your still life from scanned objects and backgrounds in Photoshop, using Layers.

> Setting up your scanner

Recent flatbed scanners have a minimum optical resolution of 600 dpi, and can create an image file good enough to output to letter size at 300 dpi. Even 300 x 600 dpi scanners will give surprisingly good results. The major difference between scanning 3D objects as opposed to flat art work is that the scan needs to be carried out with the lid open. You will need, therefore, to mask off extraneous ambient light. The easiest way to do this is to make a white shallow box that fits over the scanner in place of the lid, which is easily constructed from white card and masking tape. This allows objects to be arranged to your requirements, but prevents any excess light from affecting the scans. The white background also gives your 3D object a clean edge, allowing easier cutting out later on. Finally, use a sheet of the clearest polyacetate you can find, to prevent your objects from scratching the glass bed.

> Capture

Set your scanner to reflective mode and make an RGB scan. Good exposure is the key issue here, so ensure that your selection area is a close fit around your object. Remember you are only capturing one facet of your object, so if it has an interesting shape it will yield better results. Any delicate object that can't maintain its shape, such as a flower, will slump and crush under its own weight, but you can always suspend it with a clamp.

Brightness range, too, will play a major part in your choice, so avoid shiny objects with highlights that will burn out. Silver foils, reflective plastics, and glass objects are tricky but not impossible, and will require major corrective activity in Photoshop later on.

> Cutting out

The next step is to cut out your object from the background, and this is the most time-consuming stage of the process. Most photographers using Photoshop are apprehensive of the Pen tool, preferring simpler ways to make selections. However, once mastered as a technique, it will make you think twice about using short-cut selecting as it is the only way to make clean edged cut-outs for montages. Familiarize yourself with some keyboard short cuts first, as changing tools is time-consuming. Zoom in to at least 100% and leave your spare index finger hovering over the space bar, as this will select the Hand tool and allow easy navigation around your image. Create an enclosed path slightly inside the perimeter edge of your object and save it. A good tip for using the Pen tool is to have the History palette displayed beside your image, since it not only records each command, but describes it in words too (very useful when you've made a mistake and not realized until later). It's easy to make errors at first, but with a visible History palette, you can retrace your steps.

Make the path fit as close to the edge as you can, dragging the anchor points to describe the curves. When the last point meets up with the first, you can save it by selecting Save Path from the pop-out menu in the Paths palette. Unlike saved selections, saved paths add very little extra data to your image file as they are vector-based, rather than pixel-based, objects. You can make a path into a selection by choosing Make Selection, from the Paths pop-up menu.

> Assembly and composition

Interesting background surfaces such as paper and wood can be scanned in to provide the table top for your still life.

Scan these as RGBs, and paste in your cut-outs to start off the assembly process. Arranging the objects against your background image is the next phase, and can be a tricky composition exercise. At this point your objects will be hovering over the background, so make a drop shadow for each object to anchor it down. Use the Layer Effects Drop Shadow dialog box to achieve this effect. If it still looks fake, add another smaller and darker shadow next to the object edge to make it more convincing.

> Image adjustments

Since your objects may not be very reflective, they can look dull and lifeless after scanning. So, after cutting out, correct the contrast using your Levels slider. Many scanners produce a persistent color cast when dealing with non-standard originals, which may need eliminating through a Color Balance adjustment. The most noticeable artifacts (erroneous pixels created by the scanning process) when scanning 3D objects are the mysterious patches of red and green that appear in the highlight areas or on

reflective edges. These are a very obvious sign of a 3D original and can give away your secret. These are easily removed using the Sponge tool, pre-set to Desaturate, which drains false colors away to grayscale, leaving underlying detail untouched.

> Naming layers

As you increase the complexity of your images, the number of layers and Adjustment layers increases too, which can become baffling. Try to name each layer with a terse description of its content, Red flower for example, instead of Layer 8, which is meaningless if you forget what its content is. You can always rename layers by double-clicking the Layer icon, and entering a new name in the box. Each layer will start to eat up memory resources, so don't have more layers than you need, and merge those that are finished to reduce the file size.

digital:photography:still-life montage

> THE FISH AND WRENCH

This image was constructed out of three separate objects: a herring, a wrench, and a piece of textured paper. The fish was covered in plastic film to protect the scanner and was scanned in promptly because of the impending smell! The wrench and paper were scanned in too, at the same resolution of 300 dpi. The red/green artifacts, most noticeable on the fish and wrench, were removed with the Sponge tool. The objects were then cut out using the Pen tool, and paths were saved and made into selections which were inverted, to cut away the murky background. The separate images were assembled as different layers, and each was colored with a separate Hue/Saturation Adjustment layer. The shadow was created by borrowing the Lily selection from The Lily Wallpaper project, filling it with black, blurring it slightly with the Gaussian Blur filter, and finally dropping the layer opacity to 20%.

 The fish and wrench images after cutting out and adjusting contrast.

The background scanned in ready to assemble in Photoshop.

A layer duplicated and borrowed from the Lily Wallpaper project (see page opposite) to include in the final image.

The final image; each layer has been colored separately using Hue/Saturation.

The layer diagram for the image.

> THE HAMMER

This image was made with two simple objects: a hammer and an interesting piece of wood. The wood looked fairly bland after scanning, so it was shaded in using Selections, very like using studio lights with barn doors to create light fall-off effects. Both hammer and wood were toned using Hue/Saturation, and drop shadows were made around the hammer.

The starting point; a piece of wood scanned as a grayscale.

A hammer scanned on a flatbed and cut out ready to assemble.

The end result is colored using the Hue/Saturation dialog box, with drop shadow around the hammer.

> THE LILY WALLPAPER

This was constructed using two flat sheets, the wallpaper, and the writing paper, combined with a very three-dimensional flower head. The flower was positioned over the scanner with a clamp, to hold it steady. When scanned, very bright highlights were created on the flower surface touching the glass, which had to be removed using the Rubber Stamp tool. Surprisingly, sharp detail was captured in the base of the flower, which was two inches away from the scanner platen. The wallpaper was quite scrappy to start with and was scanned as a grayscale, so the original (unattractive) colors were omitted. It was then converted to RGB, and colored using the Color Balance controls.

A large lily flower which has been scanned, cut out, and assembled into a still-life montage.

> THE ENGRAVING

This most complex example involved seven separate objects. The small flowers were scanned in together, and were cut out using the Pen tool. They were each colored separately, then given different colored drop shadows. The Layer Effects are linked to the object layer, and move with the object when you arrange your composition. You can split them apart, too, moving shadows away from underneath the object, or even into other images, by going to Layer>Effects>Create Layer.

The scanned source material.

The end result showing the flowers and other objects cut, colored, and assembled.

digital:photography:still-life montage

>>ADDING TYPE

>Type basics

There is a standard set of typefaces or fonts supplied with your computer, which have been selected to cater for most communication purposes. Fonts have been designed by typographers to do specific tasks, but they can also be decorative and can even evoke a historical period. Helvetica and Arial are sans serif fonts, simple, and unadorned letter shapes, and are used for headlines or signage where information needs to be plain and read quickly. Serif fonts such as Times are used for text in magazines and books, where information is presented in longer statements. Serif fonts are designed with tiny triangles (called serifs) at the letter edges, to assist the eye making a speedy visual flow from letter to letter.

Type can be added to your images in many different ways, for decorative or functional purposes. In Photoshop, type is entered as a unique kind of layer, identified by the capital T in the Layer palette layer above the image. Like paths, type is made up of vectors rather than pixels, and can be re-edited even if it seems to have become part of the pixel image. In fact, it remains separate from the pixel bitmap unless you decide to make it otherwise, by a process called rendering. By double-clicking the T icon, you can re-edit your type to change size, color, and spelling at any stage. Letter characters are designed with smooth outlines, which should be aliased to prevent the pixels from appearing as a jagged staircase on the outer edge of the letter form.

The standard dialog box, showing the type modifier controls.

>The Type dialog box

To enter type, select the Type tool and click anywhere in your image window. The Type tool dialog box will appear, enabling you to select font, color size, and other character modifiers. If you check the Preview button as soon as you enter text, the type will appear outside the dialog box in your main image window. If you place your cursor in the window, you can move the type around to gauge size and color, before committing yourself. Return to the dialog box and press OK.

>Character modifiers

Type size is measured in points, a system dating back to when individual metal type characters were cast in pre-set sizes and assembled by hand. Point size is a measurement from the top of the letter character to the bottom. There are 72 points to one inch.

>Leading

Leading derives its name from the thin strips of lead which were used, in the days of "hot type," to add space between horizontal lines of type in a block of text. This extra space can make lines of text much easier to read, or help to fill space on a page. Increasing the leading to a value greater than the current point size, will create more space between the lines.

>Tracking, Kerning, and Baseline

Not every letter is the same width, the letters w and i for example. Kerning increases or decreases the space between letters; in most cases it can be left on the Auto setting. Tracking increases the gaps between letters with uniform spaces and enables you to stretch words and lines to fill a horizontal space. Baseline is only used when you need to raise or drop text from its normal line position, to create superscript or subscript effects.

>Color

The Color box enables you to select type color before typing. The default setting is the foreground color, but if you double-click on the box, you can pick a different one. If you want to change the color of already-entered text, highlight the text by click-dragging your mouse over it, then pick a new color.

> Photoshop type effects

Unlike vector-based DTP applications like QuarkXPress, type in Photoshop can eventually become bitmaps which can be manipulated with filters and blending modes. You'll notice many of the creative filters are unavailable when working on type layers, because they are vectors. If you want to apply these creative functions to your letters, you first convert the vector type into a pixel bitmap, by Layer>Type>Render Layer. After this stage, though, you can't re-edit the text.

> Stroked Type

You can create an outline around your letter shape in a different color by using the Edit>Stroke command. Use the Type Mask tool, pick a sans serif font, making it bold, then click OK. Drag into position, and Edit>Fill the selection with a color. While it is still selected, do Edit>Stroke and assign it an outline width, and a different color.

> Gradient Fills

Using the Type Mask tool again, you can use the Gradient tool to fill the type selection from top to bottom to look like an airbrushed gradient.

> Layer Effects

The Layer Effects, under Layer>Layer Effects, gives you six very good styling devices which can be used on type. They only work on text, however, that remains a separate layer.

Black letters are stroked with white to create the edge effect.

The white letter is created using the standard type tool and an outer glow layer effect applied in red.

The background is created using the Gradient tool and the Type Mask tool creates the Q letter outline. The Gradient tool is then applied inside this letter outline to create the gradient color. A layer effect outer bevel is then applied to make the image appear more three dimensional.

The image has been bucket-filled with a lilac color, then the Type Mask tool used to cut out a letter shape, revealing the white background underneath. A layer effect inner bevel has then been applied, while the selection is still active.

A layer-effect bevel is applied to this type mask selection, overlaying a textured background.

The most complex one, using two layers made from scanned paper. The Type Mask tool has been used to cut through the music paper, revealing the layer underneath. An inner shadow has been applied to this, to create depth, then the two layers were blended together using Hard Light mode and the Opacity slider.

>Type Mask

You can fill your letter shapes with an image, by using the Type Mask tool. Open an image you'd like to use for the fill, and click on it with the Type Mask tool. In the text dialog box, type a word, then press OK. Without changing tools, drag the type selection over the correct area, and do an Edit>Copy. Now Edit>Paste this into the same image or into a new one, and position it with the Move tool.

The Type Mask tool is used to create this letter. The floating type mask is layered onto a sky image, then copied and pasted into a new image window.

After colorizing lilac, a drop shadow is applied to the above example using the Layer Effects dialog box.

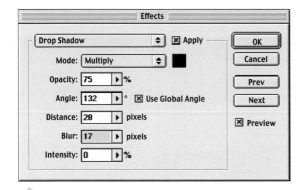

The Layer Effects dialog box.

A white letter form is created using the Standard Type tool, then the layer rendered, and a Motion Blur filter applied.

>Using filters

If you flatten your layers, or render the vector type layer by Layer>Type>Render Layer, you can apply any filter effect to the type. The example shown had a Motion Blur applied.

>Using Lighting Effects

You can light type, just like using studio lights, to create highlights and shadows across your letter forms. First you need to create a selection using the Type Mask tool, then save it by Select>Save Selection. It becomes an alpha channel and you can click into the Channels palette to see it. Go back to your image, deselect the selection, then go to Filter>Render>Lighting Effects. Now, most importantly, you need to load this alpha channel by clicking in the Texture Channel pop-up menu, at the bottom of the Lighting Effects dialog box. You will then see the letter appear in the preview window, and you can manipulate it using the different lighting types and properties. Incidentally, if you click on the White Is High button, it makes an embossed or debossed type of effect.

The dialog box for the Lighting Effects filter. This is used to illuminate type selections that have first been saved as alpha channels.

The result of using the Lighting Effects filter as above.

Chapter 9:
>>>Printing digital images

>>DESKTOP PRINTERS

Inkjet printers have now reached near photographic print quality.

>Inkjet

At a low cost, inkjet printers offer the ability to print onto many different paper surfaces. The better inkjets are those which use more than the standard CMYK colors. Epson's Stylus Photo range offers superb print quality, with the better models using a five color cartridge with Cyan, Magenta, Yellow, Light Cyan, and Light Magenta, to help emulate the subtleties of flesh tones. The photo-realistic inkjet has become the standard output device for digital photographers at a much lower cost than that of a traditional darkroom enlarger, lens, and print processor.

>Dye sublimation

The dye sublimation printer was for many years heralded as the top-of-the-range output device for digital printing. It produces a continuous tone image of very high quality, with little or no evidence of pixellation, provided that the image file is prepared at the correct 300 dpi resolution. Dye sublimation printers are either three color: Cyan, Magenta, and Yellow; or four color: Cyan, Magenta, Yellow, and Black. They work by fusing dye into specially manufactured transfer paper, making a separate pass through the printer for each color. The cost of the consumables, particularly of the dye ribbon, is relatively high, with print paper working out more expensive than equivalent-sized photographic paper. Questions have arisen, too, over the stability of the dyes over time, and when prints come into contact with certain protective plastic sleeves.

>Thermal wax

Thermal wax printers use lower temperatures to heat pigment-carrying wax from a print ribbon. They are faster than dye sublimation printers, but the thermal wax printer's major disadvantage is its reproduction of color through a halftoning or dithering process, together with an inability to use paper other than specially manufactured types.

>Solid inkjet printers

Solid inkjet printers use sticks of crayon-like ink which are heated and dropped onto paper. These devices were the first to be able to print on a wide variety of different paper surfaces. Unlike the dye sublimation and wax transfer systems, art papers of varying weights and textures can be used. On the downside, the image quality is not as photo-realistic as an inkjet, and the device does not render fine text detail particularly well.

>Color laser printers

Lasers work in a very different way from the previous devices, with the printer fusing dry pigment or toner onto papers of various surface finishes and weights. The quality of continuous tone images is not high, as different colors are created by fairly crude halftone screens. Despite the high quality of 600 dpi monochrome lasers, which are excellent for DTP, color lasers do not generally produce a sharp image, and are best used for rough layout proofs only.

Epson printers offer superb print quality at low cost.

>>PROFESSIONAL OUTPUT SERVICES

Many specialized output devices are beyond the budget of most professional photographers.

>Iris printers

The Iris printer is perhaps the most finely tuned device for making exhibition-quality, photo-realistic prints. This is a high quality inkjet, which sprays CMYK inks onto a range of specialized papers, which are fixed to a revolving drum. There are two types of print product normally offered: Fine Art or Proof print. Fine Art prints can be produced on luxurious art papers such as Arches and Somerset, both traditionally used for artists' lithographs. Many artists and photographers use the Iris process to produce exhibition-quality prints to sell editions of their images. The printer works by using variable dot sizes to reproduce continuous tone images, and very high resolutions of up to 600 dpi can be achieved for remarkable results. The IrisGPrint machine outputs the best fine art work, producing prints which are known as Iris Giclees, up to 34 x 46 inches in size. Many of these prints have already been purchased by collectors and museums of fine art. Iris technology offers the digital photographer the ability to compete with highly crafted photo-printmaking techniques, such as platinum printing.

>Print writers

A recent development is the high-quality print writer, such as the Fuji Pictrography 4000. This device works by using a laser diode to transmit the digital image onto color photographic paper. The result is a photographic print, with just the same qualities as you would expect from a print made from a color negative original. The printer uses a laser diode to "print" image data, line by line, onto light-sensitive donor paper. The image is then transferred to receiving paper, and then can be peeled apart like a Polaroid. It can produce prints up to 11 x 17 inches in size, with resolutions up to 400 dpi, which are indistinguishable from standard photo prints. The Pictrograph does not need any chemical supply or replenishment, only water, which can be seen as a more environmentally-friendly alternative. The relatively high cost of the unit makes it viable only for photographic labs, or professional photographers who spend a lot on print output.

>Wide Format inkjet

Wide format printers use an inkjet head fixed to a long set of tracking rods. Inks are held in large refillable reservoirs, which are connected by tubes to the print head. Inks are usually standard CMYK process colors, but special colors can be added, too. Maximum print size is determined by the carriage width, and length only by the paper feeding mechanism, with some devices offering near billboard-sized output. Special UV and laminate coatings can be applied to prints after run-out, to slow down the fading process. Print resolutions are relatively low but since the images are often viewed from some distance, the coarse dots are not visible. Wide format prints are economic where single prints are required, such as for point-of-sale or trade fair display materials.

>Film recorders

Film recorders use a small cathode ray tube in a light-tight box, to send digital images to negative or transparency film. Low-end desktop film recorders are useful for making intermediate negatives to run out cheap color prints. For better quality, the professional service offers much higher resolution devices, capable of 8 x 10 film output. The cost is much higher than conventional film duping, and is only viable if you need to to make a repaired version of a damaged original, to correct errors made in a commercial shoot, or to output your manipulated image for repro.

>The digital printing press

Digital printing presses, such as the Indigo, bypass the need for film separations and plates, printing directly from disk instead. Most professional design applications, such as Photoshop and Quark, are supported, and the process is very competitive for short-run four-color print jobs. The press delivers ink or toner to the paper in a similar way to a color photocopier. The advantage of the process is usually same-day turnaround at a lower cost, and because no printing plates exist, you can customize each separate print, for example with a client's name and address.

>>INKJET PAPER TYPES

With the arrival of low-cost, high quality, inkjet printers, which spray their inks onto a wide range of substrates, paper manufacturers have not been slow to react to the changing marketplace.

Both traditional photographic paper and litho paper manufacturers have entered the arena, and there is now a crossover between previously separate paper technologies. Commercially produced inkjet printing paper is made with traditional photo paper surfaces, such as glossy, matt, and satin, together with new textured, canvas, and plastic film-like materials. All require special adjustment of the printer software to achieve the best quality, and some prior testing is worth doing to avoid excessive waste.

>Paper technology

This is an enormous subject, but let's first look at the basics. Paper weight is a good indicator of thickness and is described as the collective weight of 500 sheets (or pounds per ream) as in Bockingford 250lb. Finally, paper thickness is also described in microns, e.g. 200 mic. Many printers will only work effectively on paper within a set thickness range, but because the inkjet heads can be easily adjusted to spray on thicker substrates, the better ones can cope with artist's watercolor papers.

>Mass-produced paper

Mass-produced paper is made from pounded wood pulp. The fibers are chemically broken down and mashed, to produce a pliable raw material. The processes are varied, but all use force, heat, and chemicals to help separate the fibers. The resulting pulp is funneled through a narrow slot and drawn out across a rolling belt, which ensures a continuous web or roll of paper, with all the fibers lying in the same direction. For finer papers, powdered china clay is added to achieve a smoother finish called coated stock. To prepare paper with the brightest white surface, bleaching agents are also used. Lowest grade papers have recycled matter in them, and fibers lying in many directions, with the resulting sheets less rigid as a consequence. Litho papers are manufactured for magazine, newspaper, and packaging jobs, and are not designed with archival permanence in mind.

>Art Paper

Hand-made art papers are generally made from virgin materials, including linen rags and cotton, which are boiled and mixed with water over a longer period. The watery pulp is collected in a rectangular sieve, known as a deckle, which is shaken

to mesh the fibers together, and drain excess water off. Artist's paper is coarser than machine-made papers, but smoothness can be achieved by pressing between hot or cold metal sheets. Edges can be interesting, too, with deckled or untrimmed finishes. Most machine-made art papers are pressed between textured metal rollers to impart a variety of surfaces that mimic the look of hand-made papers. The best papers are made without resorting to chemical fiber separators or bleaches, and are known as acid-free. Valuable art work, designed to last indefinitely, is best made on 50 or 100% cotton rag materials.

> Paper coating

Most papers are made with an invisible coating called size, which aids the rigidity of paper, but also affects the absorbency. In unsized materials such as blotting paper, ink will bleed severely into adjoining areas. Sized paper stops this spread from occurring, and retains the sharpness of the artist's brushwork, but can prevent the flawless absorption of ink from a desktop inkjet. Many creative photographers have experimented by first soaking paper in water to remove the size, before making prints.

When printed on uncoated papers, your images will have a lower color saturation and a slight loss of sharpness, due to higher ink absorption and the non-reflective nature of the paper. Shiny papers reflect more light, enhancing color saturation and shadow depth. The ivory tone of many art papers will also reduce the contrast of your images. The paper base becomes the maximum highlight brightness value (as white ink is never used), so you may need to think about increasing the contrast of your image to compensate.

> Drying time

Each type of paper will take some time to dry and it is worth testing a small batch of new materials first, before purchasing in any quantity, especially if you intend to run off lots of prints. The cause for delayed drying is an incompatible match of ink and paper type, and certain papers can take up to a day before they lose their tacky nature. Don't forget that your print will change color when it is dry, as it is more reflective when wet.

> COMMON INKJET PAPER TYPES

> Plastic films

High gloss film is able to hold the finest of inkjet dots, without excessive spread or absorption. It can be used with the printer's maximum output resolution of 1440 dpi. Transparency film is also available, which gives a weak color image, barely suited to overhead presentations.

> Photo-quality glossy paper

This is the most common paper, manufactured by all the leading companies in a variety of weights and base colors. Thicker weight paper enables you to make color prints that feel as substantial as double-weight fiber-based photographic paper.

> Coated or matt papers

Coated papers have smooth, matt surfaces made with fine china clay compressed into the surface layer. This minimizes dot spread, enabling fine detail to be held, particularly where text is involved. Colors will be less saturated than on glossy papers, but have a quality all of their own.

> Copier papers

Designed for xerox or laser printer use, this low grade material is highly unsuitable for inkjet use, and resulting prints will be waterlogged and have a fuzzy image quality.

> Watercolor papers

Many companies produce watercolor-effect papers, enabling photographers to make color prints on textured surfaces. One of the best is Kentmere Tapestry, which has the same surface texture and weight as Art Classic photographic paper.

> Artist's canvas

A cotton canvas which has a special coating to absorb ink, yet holds image detail, is manufactured by Page and is called Artist's Grade Canvas. Standard unprepared artist's canvas is not a suitable material to feed through your printer.

>>CONTROLLING IMAGE QUALITY

Inkjet printers need as much setting up and testing as a conventional color darkroom.

The self-correcting nature of most printer software should not be exclusively relied upon, particularly when unusual print problems occur. Inkjets have a limited number of ink colors, usually four or six, which are used to reproduce the palette of 16.7 million colors. Color is achieved by a process called dithering, where minute ink dots are placed in varying proximity, making the human eye "mix" the colors visually. The print head lays down ink in very fine horizontal lines, one for each color.

>Printer resolution

Most printers can be set to work in lower quality mode for producing roughs or proof prints. A printer resolution of 360 dpi sprays fewer dots on the printing paper, regardless of your image resolution. Results will be grainy, with obvious spaces between the dots. Highest quality print is achieved with 720 or 1440 dpi and should be used for photo-realistic output.

>The printer software dialog box

It is very important to match the type of paper you intend to use with the nearest Paper Setting, as this determines how much ink is sprayed onto your paper. Plain paper, which is very absorbent, needs very little ink before image spread occurs. If you choose the wrong paper type setting, you may end up with a heavy and soggy result.

>Error diffusion and fine dithering

Halftoning is a method of mimicking continuous tone color using limited inks. Error diffusion and fine dithering are two halftoning methods used by inkjets. Error diffusion creates a random pattern of dots to mimic subtle color distribution, and is the best method for reproducing photographic images. Fine dithering allocates dots in a uniform pattern, and is best used for printing graphics and solid color areas.

Detail of a print, with close-up inset, which has been erroneously output at 72 dpi.

Detail from a print which has been erroneously made in Draft quality mode.

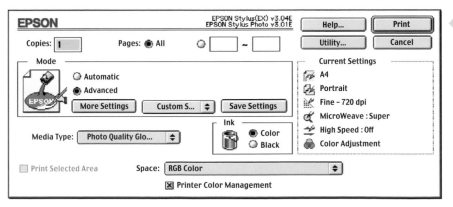

The dialog box for an Epson Inkjet printer, showing the general settings for photo-realistic printing.

> Microweave and super microweave

This process ensures the separate lines of ink mesh together, rather than remain visibly apart, as with early inkjet devices.

> Evaluating color casts

The same image file printed onto two different papers, using identical settings, will not look the same. The complex paper manufacturing process produces surface coatings which react to printer ink and cause color imbalance. As with a photographic print, this color cast can be removed using the Color Balance adjustments in the printer software. Color casts are best observed in the print's neutral color areas, and only under daylight viewing conditions.

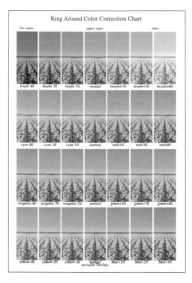

This Ring Around chart is printed to determine the correct color correction. The document was made with a Photoshop Action file which copied and pasted a portion of the image into a new document with a precise color balance adjustment. Once Action files have been designed and recorded, they can be replayed on subsequent images.

> Color adjustment

Despite the correct appearance of your image on the monitor, unusual print media may require extra adjustments to combat color imbalance, print density, and contrast. As these adjustments correct the paper's characteristics, not the image file, they are best made in the printer software dialog box. An optimum setting could then be deduced after careful testing for different paper types. The setting can be saved as printer setting preferences, independent from your image, and recalled at a later stage.

The dialog box, showing the color adjustment options, useful for matching paper types.

> Testing the range of your printer

Your inkjet paper will not be able to cope with the extreme ends of the brightness scale, producing holes in the highlights and growing shadow areas. Different papers will display different characteristics with different printers and inks, and these are not usually outlined in the accompanying technical specifications. It is essential, therefore, to test the paper's ability to reproduce tonal and color scales first.

> Printer maintenance

Most printer software incorporates utility programs to help you maintain high print quality through a software interface. Printer head cleaning can be necessary from time to time since the nozzles become blocked, particularly if the printer has not been used for some time. Printer head re-alignment can be necessary, too, if vertical out of register lines appear, usually after printing onto unconventional media.

Common print problems	Diagnosis
Excessive color casts, fine lines missing.	Ink run out.
Image shapes bleeding into one another.	Wrong paper setting.
Image is grainy.	Lowest quality printer resolution.
Image has blocky pixel shapes.	Low image file resolution.
Visible lines or out of registration.	Printer head out of alignment.
Print banding.	Wrong media set.

> Making a step wedge

A good way to test the range of your printer is to make a step wedge for each of the four CMYK printer ink colors. The wedge shows how the printer copes with the heavier and lighter ink values. Once you have made a standard step wedge, you can save and use it with other printers or other papers to determine their individual charcteristics. For the extreme ends of the wedge, from 0-10% and 90-100%, make the steps in 2% increments.

To start, make a new document and from the View menu select Show Grid and Snap to Grid. To fill each step with the right color, enter numerical values in the Color Picker, in the CMYK text boxes at the bottom right of the dialog box. Using the rectangular Marquee tool draw a small rectangle, and Edit>Fill with 100%. Repeat the process, reducing the color percentage each time and use the Snap to Grid to keep your rectangles identical.

>>> Analysing the wedge

Your printer will not cope very well with 0-5% or 95-100% and these individual steps may not show up on the wedge. If your shadows start to fill in after 95%, you can pull back the maximum blacks to this 95% point, using your Curves to compensate.

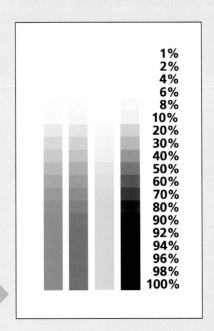

A step wedge.

With RGB Curves, the scale is displayed as 0-255. Drag the black point until the Output box reads 12 (equivalent to a 5% reduction).

For images in different modes, the process is slightly different. For duotone, grayscale, and CMYK images, you can easily drag the black point on the curve until the Output box reads 95%.

The Color Picker dialog box showing where to type in ink values, when making a step wedge.

>Light-fast inks

Inkjet prints are not known for their archival properties. Deterioration occurs because of an unforeseen reaction between the paper coating and ink pigments. Light-fast ink cartridges can now be installed in most popular printers and claim to extend the lifespan of a print considerably. Much testing has been undertaken in the professional photographic press, with the conclusion that further research needs to be done to design an archival ink and paper combination that is suitable for commercial photographic uses. Lyson inks and papers claim a life expectancy in excess of conventional color coupler prints.

>Inkjet cartridges

Most inkjet cartridges can be refilled with cheaper third-party ink, except those which use pressurized containers. These non-standard inks may not, however, use the same pigments in the same quantity as the standard cartridges, and you'll get inferior results for a comparatively small saving. A growing market has arisen for specialized cartridges filled with unusual colors, which can be used to mimic vintage photographic processes such as bromoil.

>Early photo processes

Many nineteenth-century photographic processes were accomplished without the use of silver-based sensitive materials. Pigment, bromoils and gum bichromate all used various coloring agents to make delicately-colored prints from photographically prepared negatives. Inkjet printers have therefore enabled photographers to come full circle and make photographic images without the use of silver. Silver images have never been as stable as pigment-based images, such as oil paintings, and the next years of ink research will produce some very exciting products.

>> USEFUL PRINT TECHNIQUES

You can work in Photoshop as you would in a darkroom, making test strips and contact prints from your files.

>Print preview

Most of us are used to working with fixed-size documents in word-processing applications. When it comes to guessing how big your digital image will print, it becomes a little more complicated. Print size can be altered to fit your paper by lowering or raising the image resolution (without re-sampling) in the Image Size dialog box. An even easier way of seeing how big the image is going to print is to click and hold the document size readout bar (such as Doc: 1.36M/1.36M), found on the bottom left of your image. A small pop-up page appears, indicating how big your image will print on the current paper size set up in your printer.

A print preview of the image, depending on the paper size set-up.

> Making a test strip

Epson inkjet printers can print a rectangular selection of an image, rather than the whole document, enabling a much smaller test print to be run off first. Make a selection with your rectangular Marquee tool that covers highlight, mid-tone, and shadow areas, just as you would in the darkroom. When sending to print, check the Print Selected Area, as shown. Since the selection is small, you could even economize and print on smaller paper.

 A small proof print made from a selection.

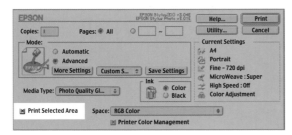

 The printer dialog box to print the above test strip.

> Making a contact sheet

Most of us don't remember exactly where our digital images are stored. This problem is further compounded when you start saving images onto different drives and disks. In conventional photography, a contact sheet is made to represent all the images on a single roll of film, helping you to track down the right frame quickly. With digital images, no such quick visual preview exists, particularly if the files are saved without picture icons. An easy way around this is to print off a contact sheet that represents the contents of a directory, folder, or CD.

Photoshop has a useful automated action called Contact Sheet which creates such a page for you while

 An automated Photoshop command produces a contact sheet from a nominated folder/directory.

 The dialog box for the automated action.

you watch. Go to File>Automate>Contact Sheet and you are presented with a dialog box. Here you can specify the source for your sheet, in this case Disc 1, a CD of image files. You can determine the layout of your sheet, too, deciding how many contact-sized images, known as thumbnails, should appear on the page. Make the contact sheet the same size as your print paper and set the

resolution to match your print device. You could even specify a paper size which will slot into a CD-R case exactly, giving you a quick visual reference for each disc. The image file could also be optimized and attached to an e-mail if you want to present proofs to a client.

The action works by opening each original image file, resizing it, copying it, then pasting a smaller version into the new document, together with the file name. It will close the original images afterwards, without saving any of the changes. The process is memory-intensive, and can take some time if you have high resolution images or multilayered Photoshop files. Like many action sequences in Photoshop, you can leave them to run by themselves.

> Making a multiple print

Traditional portrait studios and wedding photographers often supply their clients with multiple prints of the same image on one sheet of paper. To create such a complex layout can take some time, involving increasing the canvas size, resizing, then copying and pasting. Photoshop can do this for you with another automated action called Picture Package. It works like the Contact Sheet action and you can pick one of eleven layouts to make multiple printing quick and easy.

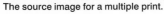 The source image for a multiple print.

 A multiple print using the Picture Package action.

 The dialog box for the Picture Package action.

> Custom paper shapes

The size of print you can produce is limited only by the printer's carriage width. Custom paper sizes can be cut from larger sheets, particularly art papers, and set up in the printer software dialog box. Panoramic paper shapes up to 30 inches long can be fed through most printers, but it's worth checking your ink reserves first, in case it runs out halfway through. Individual book sections can be printed, too, as double-sided paper is fed through for a second time, before folding and assembling in sections. In this way, hand-made photographic books can be printed from your desktop. Increase your canvas size to account for the non-printing white space, and remember that once you have turned the paper over to feed it through a second time, you'll need to check its orientation, or the second image will print upside down.

digital:photography:useful print techniques

Chapter 10:
>>>Web pages

>> WEB PAGE BASICS

A web page is contructed from separate elements such as text, color, and image files.

Precise arrangement of these items is achieved using HTML (Hyper Text Mark-up Language). Just as binary code records information for color pixels in a digital image, HTML code defines the placement and display of elements on a web page. Browser applications such as Netscape Navigator and Microsoft Internet Explorer interpret this HTML code, displaying the pages downloaded from a web server on your monitor. HTML files are tiny and download quickly, as they only carry the instructions for displaying data files, and not the files themselves. Digital image files are much larger and when a page loads slowly it can often be traced to it containing large or multiple images.

>URLs

A Unique Resource Locator, as its name suggests, is something like a telephone number that allows you to connect to any web site, web page, or image file published on the Internet. When you "dial up" a web page, you connect to the files on a web server. If you misspell a URL, you'll be connected to a different destination if it exists. Browers display the current URL across the top of window starting with http://.

>The web page

A web page is not one large picture file from edge to edge, but many different files displayed simultaneously. There's also no fixed page dimension and you can create a web page which can be as long as you like. In practice, pages are commonly designed to fit the standard size 640 x 480 monitor, with links to additional data on separate pages.

>Links

Most web pages contain links, such as underlined words or button-like graphics, which take you to another web page or site. Making links is a simple case of nominating the button and the destination file. When you click on a link the browser loads that file from the web server, replacing the current page. Web surfers rarely navigate a site in a linear fashion, like reading a book, but skip from link to link.

The layout of a typical web page.

The logo, the quote, and the buttons on the author's home page are all made from image files created in Photoshop.

> Pages assembly applications

To make your own web page, you can either compose in HTML code, or use an assembly application such as Microsoft Front Page, which lets you drag and drop your designs, like a DTP application, while it writes the code for you. For a novice, this is the easiest option.

> Thumbnails

Many photographers use tiny, contact-print-sized versions of their images, known as thumbnails, as buttons to link the user to larger and better versions of their images. This prevents long download times, waiting for the full page to appear when you first open the web page.

> Web-safe color

Like the Pantone system for ink colors, there is a universally acknowledged system for accurate color reproduction over the Internet. Potentially your web page could be viewed on thousands of different monitors each with their unique color limitations. Web designers assume that 256 will be the minimum color display used. However, PC and Mac operating systems use two different sets of 256 colors, with only 216 values in common. The 216 colors are called the browser safe palette and can be selected in Photoshop in the Color Picker or made into a Swatch.

> Dithering

If your pages are made with non-safe colors, they will be converted by the surfer's computer to an approximate value. The process, called dithering, breaks complex colors into a pattern of dots, creating disappointing effects with bright color.

> Decipher the jigsaw

Web pages are constructed by a jigsaw-like arrangement of images and text. You can easily look at the individual pieces by separating them from the page. With Netscape Navigator, place your cursor over an image and hold your mouse down (Mac) or hold the right button down (PC). From the pop-up menu, select Open this Image. You can then see the image by itself. In Microsoft Internet Explorer the process is identical, but choose Open Image in New Window instead. This is a useful process, as you can see how the experts have constructed their own pages.

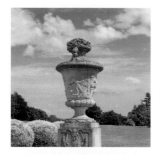

Converting photographic images into GIF's can produce a range of alarming results.

Image optimized with no dither, 16 colors, 89k.

Image optimized with Noise dither 100%, 16 colors, 245k.

Image optimized with Diffusion dither 100%, 16 colors, 194k.

Image optimized with Pattern dither 100%, 16 colors, 165k.

>> WEB IMAGE FUNDAMENTALS

Small file sizes need not mean low image quality, providing you stick to the rules.

> File size

When you connect to a web page, the image files are sent from the web server to your computer, via your modem or ISDN line. Image files are much larger than text files, and consequently take much longer to download. The majority of web users still have slowish 28.8 modems, but expect pages to download instantly. They will be inclined to move to another site if your image files have been badly prepared and are too large. Optimizing images ensures that your files are reduced to a size that transmits quickly, takes up little storage space on your web server's hard drive, and uses less RAM resources on a surfer's

computer. Two major factors determine the data size of digital images: the size of color palette used, and the image resolution.

> Image resolution

So far you will have prepared images with a resolution of 300 dpi for litho output, or 200 dpi for inkjet output. As web images will only be viewed on a monitor, you must make it 72 dpi. If your image is at a higher resolution, resample down by using Image>Image Size. Now at 72 dpi, you will notice a huge reduction in your image's data size.

> File formats

To display your images over the Internet, you must first save them in a file format which is recognized by common browser applications such as Netscape and Internet Explorer. These different file formats are designed to compress data in very different ways.

>>> GIF (Graphics Interchange Format)

The GIF format is used to save images which have solid color areas, or sharp-edged shapes. Most graphic images on a web page, such as buttons, logos, and advertising banners, are created using text and simple colors, and are GIF files. When saved in GIF format, large reductions in image size take place, and a simple GIF image in a web page could be as small as 5K. The GIF format is not suitable for saving continuous tone images, such as photographs, or graphics with subtle gradients. This format reduces image data by squeezing the 24-bit 16.7 million color palette, down to 8-bit and 256 colors, or less. Photographic images saved as GIFs look posterized and blocky, which gets worse as the palette size drops. The process uses a "lossless" compression routine, meaning images can be resaved as GIFs without any

further deterioration in image quality taking place. Saved with a file size not much greater than one single frame, the format is a very efficient way to make basic animation for the web.

Other types of GIF file can be created, such as the GIF89a, which allows you to save images with a transparent background. This is useful if you want to create cut-out images that are not surrounded by a white border, and let the web page's background color fit around the irregular image edge. GIF images can also be animated, not like a sophisticated cartoon movie, but more like a simple flick book. Saved with a file size not much greater than one single animation frame, only the changes between frames are saved.

The starting point, 300 dpi 24-bit RGB TIFF, 2.5MB.

Image optimized as GIF, web palette, 8 colors, 100% dither, 15K.

>File formats

>>> JPEG (Joint Photographic Experts Group)

The JPEG file uses a 24-bit palette, and compresses differently from GIF by discarding image data. This is known as a "lossy" compression routine, and it is used to reduce photographic images to a manageable data size, without causing colors to posterize. It is unsuitable for images with sharp-edged elements such as text and logos, as it transforms them into softened or blurred shapes. You should keep your image in its original TIFF or Photoshop format, and only change to JPEG format as the very last step. Resaving a JPEG file means image quality will get progressively worse. JPEGs don't deteriorate with extended use over the Internet, viewers merely open and close image files on the IP server.

You can control the extent of compression by nominating a value on a scale, usually from 1–10, or 0–100 in better applications. Higher settings drop less data and retain better image quality, but file size savings are not so great. Lower settings drop more data and reduce file size considerably, but at the expense of image quality. Before the advent of preview windows, found in Photoshop 5.5 and ImageReady, compression was very much a hit-or-miss affair, with results not evident until you had committed yourself to a setting. Certain image artifacts are an inevitable byproduct of the JPEG saving routine, notably the banding of subtle gradients and tone. It is best to prepare your image with these limitations in mind.

>>> PNG-8 and PNG-24 (Portable Network Graphics with 8- or 24-bit color)

The PNG format is a recent introduction which is not yet supported by all major browser applications. The format combines the sharpness of a GIF with the subtle color reproduction of a JPEG. The advantage of using PNG-24 is that it is a lossless compression routine that allows transparent edge effects to be created. File sizes for 24-bit photographs saved in the PNG-24 format will be larger than if saved as JPEG, but PNG-8 format compresses images more efficiently than GIF. Both PNG formats allow extended transparency effects.

>>> Progressive JPEGs and Interlaced GIFs

A Progressive JPEG is a variant where the image loads from your browser in two stages. A low-quality version appears quickly and holds the surfer's attention, while the better version downloads.

The starting point: 300 dpi, 24-bit RGB TIFF, 2.5MB.

Image as JPEG quality 0, 29K.

Image as GIF, web palette, 8 colors, 0% dither, 57K.

Image as GIF, web palette, 94 colors, 0% dither, 133K.

The starting point: 300 dpi, 24-bit RGB TIFF, 2.56MB.

Image as JPEG, quality 30, 19K.

Image as a GIF, web palette,19 colors, 0% dither, 25K.

Image as a GIF, web palette, 216 colors, 100% dither, 229K.

>> OPTIMIZING IMAGES IN PHOTOSHOP

Precise controls for creating web images take all the guesswork away.

>The Save For Web Preview

If you are starting from a 300 dpi high resolution image, reduce the resolution down to 72 dpi first, and decide how big you want your image to appear on screen, by reducing the "print size." Here there's less confusion over image size, screen size, and print size, since your image viewed at 100% will be the same size as it appears on your web page.

By going to File>Save For Web, you can preview how your image will look, before the compression routine changes your file. The preview window gives you a grid of up to four variations, each produced with a different compression routine, enabling a side-by-side comparison. For photographic images, use JPEG high- or medium-quality settings, with the optimized button checked. Once you've decided which one of the four looks best, click on the image and press OK. You now have the chance to rename the file, or even save it with its own HTML page, ready to include in your larger web site. You can view the image in your default browser by clicking the browser icon at the bottom right of the window. Surprisingly, the example image was reduced from 226K down to a mere 11.15K while still retaining sufficient detail.

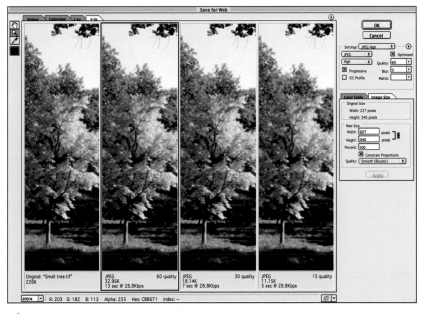

▲ The dialog box and image previews in Photoshop used for comparing different optimizing routines.

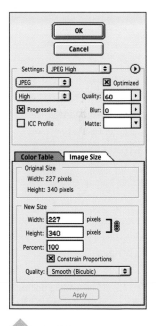

▲ Detail from the image, showing the optimizing controls.

← A further option is to determine the target file size of your image.

GLOSSARY

Artifacts

Erroneous pixels created during the capture phase of imaging, caused by electrical interference or physical barriers such as dust.

Bit

Bit is the smallest unit of computer data, either 0 or 1 in binary numbers, or "on" or "off" in electrical terms.

Bit depth

A measurement of the number of bits used to create a single pixel in a digital image. A 24-bit RGB image is created from a palette of 16.7 million colors.

Bitmaps

Pixels are mostly square in shape, and an image created from a grid of these individual units is called a bitmap.

Byte

A byte is a binary number made from 8 bits. An 8-bit number describes 0-255 in the decimal scale. The memory or storage space in a computer is measured in bytes.

CCD Charged Couple Device

A light-sensitive receptor cell which converts light energy into (analog) electrical currents which can then be converted to digital information. Groups of CCDs are arranged in rows or matrixes to form a CCD chip. Each cell, or photosite, as they are known, is responsible for the creation of an individual pixel. CCD chips are found in digital cameras and scanners.

CCD linear-array

A strip of light receptor cells, or photosites, which is moved across a stationary object by motor, to capture an image of it line by line. Linear-array CCDs are typically found in flatbed scanners.

CCD matrix-array

A grid of light receptor cells, or photosites, commonly used in digital cameras because of its ability to capture an image instantaneously.

CD-R Compact Disc–Recordable

These are CDs on which large volumes of data are stored or written. They can be read many times but cannot be over-written.

CD-ROM Compact-Disc-Read-Only-Memory

These are a special type of CD which can store up to 640MB of data. They are commonly used to distribute software, multimedia titles, and digital image collections. CD-ROM drives can transfer data at a rate of 3.6–5.4MB per second, referred to as 24x or 32x. Compare this to a transfer rate of 150K per second, or 1x, for an audio CD.

CD-RW Compact Disc–Read-Write

These offer the same advantages as CD-Rs with the added advantage that data can be erased and re-written.

CMM Color Management Modules

This is software, such as Apple's Color Sync and Kodak's Color Management System, that attempts to regulate the display of color.

CMYK Cyan, Magenta, Yellow, Key

Cyan, Magenta, Yellow, and Black (historically called the key color, hence K) are the standard inks used in the lithographic printing industry to reproduce color images.

Color space

Describes the mode used to represent color such as RGB, CMYK, or Lab. Each space has its own unique limitations.

CPU Central Processing Unit

The CPU is the "engine" of a computer, responsible for calculating the complex commands involved in manipulating data with a speed measured in megahertz (MHz).

CRT Cathode Ray Tube

The CRT is a vacuum tube used as a display screen in a monitor or television set. The inner surface of the CRT is coated with phosphors, which glow and produce light when hit by an electron beam.

Dot pitch

Describes the distance between the perforations on the monitor's shadow mask. The better displays usually have a dot pitch under 0.28mm. As with fine halftone screens, the smaller the dots, the sharper the image.

Dynamic range

Describes the extent of tone capture in sensitive materials and recording devices.

File extension

These are the three letters appearing after your filename which denote the file format. File extensions are essential when you need to swap data between computers with different operating systems, such as from a Mac to a PC.

FireWire (also known as IEEE 1394)

A connector used to download digital data at extremely high speeds from a high end digital camera to a computer.

Grayscale mode

Grayscales are black and white images created from a limited palette of 256 tones, i.e. black, white, and 254 grays.

Halftone

A method of printing a continuous tone image, such as a photograph, using a screen of tiny dots. Used in inkjet and lithographic printers, only

four CMYK process colors are used. Once printed and when viewed from a distance, the human eye perceives these tiny dots as a continuous tone.

Hardware

The collective term for the physical units of a computer system such as the monitor, mouse, and processor.

ICC profiles International Color Consortium

A profile is a list of characteristics that describes a particular color space such as the space of an Apple 13-inch monitor. ICC profiles are interpreted by Color Management Modules, when your image is viewed on a monitor in a different workstation.

Interpolation

A process that uses software to add new pixels to the mosaic-like bitmap of an image or part of an image. The color of the new pixels is derived from the original adjacent pixels. Interpolation appears to increase the original resolution and quality of an image.

ISO International Standards Organization

ISO is taken from the Greek word *isos*, meaning equal. The speed or light sensitivity of conventional photographic film and of the CCDs found in digital cameras, is measured in ISO values. Lower ISO numbers indicate slower films, or lower CCD ratings which require less light to be correctly exposed.

Lab color mode

Lab mode describes a theoretical color space where color and brightness are split into three different channels, two for color and one for brightness.

Lossless compression

This is a way to reduce image data, but without losing visual quality. TIFF and GIF both use lossless compression routines.

Lossy compression

This is a way of reducing image data, but at the expense of visual quality. JPEG uses a lossy compression routine and the quality of the image deteriorates each time you resave.

OS Operating System

Operating systems are what control computers, enabling software to interface with computer hardware and also providing the means to perform a number of routine tasks such as formatting a disk and erasing files. Mac OS and Microsoft Windows are two examples of commonly-used operating systems.

PCMCIA card Personal Computer Memory Card International Association card

Known as a PC card, this is a mechanical mini hard disk, used in professional digital cameras to store image data.

Peripherals

Peripherals is the term used for additional hardware devices connected to a computer such as a scanner, printer, monitor, or keyboard etc.

Pixel (from PICture ELement)

A pixel is the smallest unit of a digital image. Mainly square in shape, pixels are arranged in a mosaic-like grid called a bitmap.

RAM Random Access Memory

Memory is the area of a computer where data currently being used is held for quick access. This data is lost, however, when the computer is turned off or when it "crashes."

RGB mode

This is a common mode for color images, where each pixel is described by a mixture of Red, Green, and Blue values.

SCSI Small Computer Systems Interface (pronounced "scuzzy")

This is a method of connecting external and internal devices or peripherals to your computer.

Scratch disk

This is a portion of your hard drive (or other drive that you nominate) that is used to store less urgent data, leaving the quick access RAM memory as free as possible.

Shadow mask

The sharpness of the image created on your monitor depends on a kind of internal stencil screen called a shadow mask; a thin sheet of metal with minute perforations.

SIMMs and DIMMs Single Inline Memory Modules and Dual Inline Memory Modules

A SIMM is a circuit board which holds RAM chips, generally found in older machines. Nowadays these have been largely replaced by DIMMs.

UPS Uninterrupted Power Supply

UPS systems create a back-up power reserve which gives you time to save and close down your work after the main power supply fails.

USB Universal Serial Bus

Like SCSI, USB is a system designed to attach different peripherals to your computer, but with much faster data transfer rates.

VRAM

Video RAM is a separate piece of high speed memory, that stores the screen data and is essential for a high quality color display.

INDEX